FASHION:THEORY ★ LUSTRUM PRESS

EDITED BY CAROL DI GRAPPA

ALL RIGHTS RESERVED UNDER INTERNATIONAL
AND PAN-AMERICAN COPYRIGHT CONVENTIONS.
PUBLISHED IN THE UNITED STATES OF AMERICA
BY LUSTRUM PRESS, INC., BOX 450, CANAL STREET
STATION, NEW YORK CITY, N.Y. 10013
COPYRIGHT©1980, LUSTRUM PRESS, INC.
JOHN FLATTAU, RALPH GIBSON AND ARNE LEWIS

MANUFACTURED IN THE UNITED STATES OF AMERICA
LIBRARY OF CONGRESS CATALOG CARD NUMBER: 80-81181
ISBN: 0-912810-28-9 (HARDCOVER) 0-912810-29-7 (PAPER)

TYPOGRAPHY BY THE STUART FINE CORPORATION
PRINTED BY RAPOPORT PRINTING CORPORATION
BOUND BY SENDOR BINDERY, INC.
DESIGNED BY ARNE LEWIS

LASHED, BUT NOT LEASHED

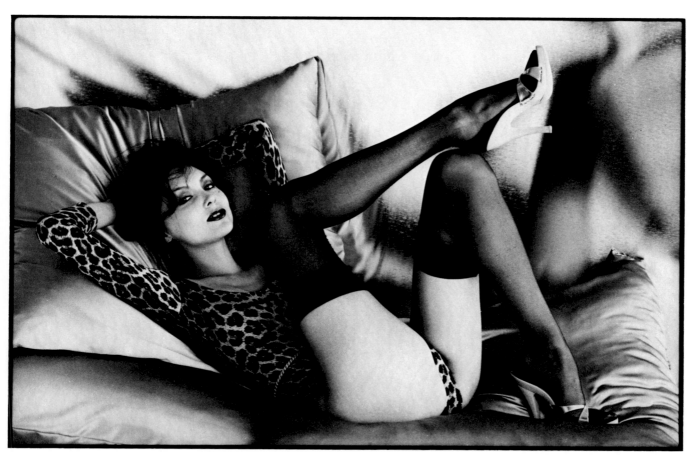

MARIE IN THE LEOPARD SKIN

"Fashion is a bitchy business."

DAVID BAILEY

When I was 12, I wanted to be an ornithologist but for a cockney in the East End of London to look at birds through binoculars was very suspect. In my father's eyes, I had to be queer as a coot. The Walt Disney films started me taking bird pictures that I processed in my mother's cellar, an old air raid shelter from the war. Then I lost interest in photography until I was 16 and started playing the trumpet and dreaming of being Chet Baker. Some fantastic record covers out of California made me want to take pictures again but I didn't have the money to buy a camera.

When I was 18, I was drafted into the Royal Air Force and ended up in Malaya and Singapore, where cameras were cheap. I bought a 2¼ x 2¼ Rollop that was a copy of a Rolleiflex, and a Canon that was a copy of a Leica. I used to hock them to process my film. Every two weeks, on payday, I'd get my cameras out of hock, buy film and take pictures for a week.

After two years in the service, I went to work for an advertising photography studio, sweeping floors. In 1958, unless one was upper-middle class, getting started was difficult, but I looked around and found eight photographers who were good, and wrote to them. My first answer was from John French, one of the best, inviting me for an interview.

John French looked like Fred Astaire. "David," he said, "do you know about incandescent light and strobe? Do you know how to load an 8 x 10 film pack?" I said yes to everything he asked and he gave me the job but, at that time, I didn't even know what a strobe was.

We became friends and after 6:00, Mr. French became John. One night I asked why he gave me the job. "Well, you know, David," he said, "I liked the way you dressed." I used to wear a leather jacket and high-heeled cuban boots. Six months later, everyone thought we were having an affair, but in fact, although we were fond of each other, we never got it together.

During the eleven months I was with John, I learned more about attitudes and how to deal with clients than about photography. John never touched a camera during the shooting. He would stand next to it and say, "Still," and I would flick the shutter release.

While I was an assistant, the DAILY EXPRESS was running a full page of my pictures every Thursday, and I was working for a magazine called WOMANS OWN. Then, one day, John Parsons, the art director of ENGLISH VOGUE, called and asked me to be one of their staff photographers. Not out of arrogance or playing hard to get, I said no, because they were offering me less per week than WOMANS OWN was paying me per picture. I didn't realize that VOGUE was different from any other fashion magazine.

Parsons called again three months later and offered me a contract which paid by the picture. In late 1959, I started doing the small shop hound pictures in the front of the magazine.

Twelve months later, I walked into the VOGUE studio and saw Jean Shrimpton doing a Kellogg's advertising shot with Brian Duffy. "God, Duffy," I said, "I wouldn't mind a slice of that one." "Forget it," he said, "she's too posh for you. You'd never get your leg across that one." We bet ten bob, a lot of money when you're breaking the ice to have a shit. Three months later, I was living with her.

The photograph of JEAN IN THE PHONE BOX was shot in January, 1961, in New York, with a Pentax and a 135mm lens. To give you an idea what it was like then, the editor at ENGLISH VOGUE phoned me up before we left, and said, "Don't wear your leather jacket at the St. Regis. Remember, you represent ENGLISH VOGUE." When we arrived, Alexander Liberman, the art director of AMERICAN VOGUE, said, "Your pictures need more direction. You're all over the place." He was probably right because, after years of Rolleiflex, 4 x 5, and 8 x 10, I'd just discovered the Pentax, and was more excited about all the lenses than the content of the picture. Anyway, the outcome was that Liberman gave me a contract with AMERICAN VOGUE.

More than any picture I've made, JEAN WITH THE WILD HAIR personifies the 1960's. It was shot in 1963, for my book DAVE BAILEY'S BOX OF PIN-UPS, with a Hasselblad and a 150mm lens. As a matter of convenience I generally use 4 x 5 or a Hasselblad in the studio and 35mm on location.

The light is tungsten, a Mole Richardson 1000 scoop on the front and four lamps on the back. The only time I used strobe was for AMERICAN and ENGLISH VOGUE in the 60's. The film was Tri-X and the print contrasty because I read Penn liked blacks and whites. So did Bill Brandt and Von Sternberg.

SHRIMPTON WITH HANDS AND HAIR is a straight crib of a Steichen. Of course, there was a special magic because I loved her. A model doesn't have to sleep with a photographer, but it helps. Jean was the greatest model I've worked with. Sometimes we shot three dresses on one roll of film because I was sure that I'd got it.

In the early 60's, everything was shot on Tri-X rated ASA 800 for a grainy effect. Later, I went through an FP-4 phase, thinking it had more tones and less grain. I've gone back to Tri-X, and hate to say it, because Kodak doesn't give a shit about professionals, but Tri-X is the most versatile film there is. It can be rated from ASA 25 to 2000 and give the same quality as any other film.

The photograph was shot for Bea Feitler when she was at QUEEN MAGAZINE, before she went to VOGUE. It was 35mm and

cropped. I always crop in the camera, but not out of any Cartier-Bresson pretension. Art directors crop all the time, and if it works cropped, why not? A fashion photograph is just an illustration.

Composition is never as important to me as the way a girl looks. My strongest pictures were always fashion portraits in the studio against a white background. I worked with the same five girls all the time, photographing them as people, not fashion models. My style is reflected in the peculiar personalities of my models more than in any one fashionable technique. I'm styleless but my girls aren't.

All the women I've photographed have influenced me as much as I've affected them. People say a photographer creates a model, but if she hasn't got something, there's no way to create her, like a Liza Doolittle. I work with a girl to try to bring out her personality and mood.

In a way, working with me is a disaster for a model who wants to make money in advertising. Penelope Tree or Marie Helvin can't be used for a Max Factor or Avon ad because people recognize them as personalities, rather than as girls they can look like. Their only possibility is for someone like Charles Revson to give them a big contract. None of my girls have had a commercial look, except for Jean. She was lucky because everyone could identify with her.

When Diana Vreeland came to VOGUE in 1964, she sent for Jean and me. "Shit, I'm out," I said. "She's bringing Avedon with her from HARPER'S BAZAAR." That morning, Jean and I were having an argument and we couldn't find a taxi in the pissing rain. As we walked the four blocks from the Tudor Buildings to the Graybar, all Jean's make-up began to run down her face, and I got wet as an alley-cat. Jean said, "We can't see Vreeland like this." I thought it was better to turn up than not. It was like having an audience with the Pope.

As we walked through the door, into Vreeland's magic lacquered cave, she said, at the top of her voice, "Stop! The English have arrived." I thought she was the most dramatic woman I'd ever met and, in a way, she invented the English mystique in America. "In the future," she said, "you take pictures that sell frocks. If you want to sell images, go work for HARPER'S BAZAAR or POPULAR PHOTOGRAPHY."

Penelope Tree was discovered by Vreeland, and I started working with her about 1965. Instead of taking 10 pictures a day, we'd spend the whole day in the studio on two pictures. I'd be pleased with them and take them to Vreeland. She'd say, "Bailey, they're divine, you've exceeded yourself. Penelope looks beautiful. But, of course, I can't use them." I'd ask why not.

"Bailey, darling," she'd say, "I don't have to tell you. Look at the lips." "Well, what's wrong with them?" I'd ask. "Bailey, darling, can't you see?" she'd say. "There's no languor in the lips."

Vreeland and I always argued about the white background on the VOGUE covers. A colored background was never used, but I got the first blue background in ten years, and only because the model wore a white hat. Covers were tricky business. On the same day, six photographers shot a cover. At that time, it was always Bert Stern, Avedon, Penn, myself, and the trendy young photographers living with models that VOGUE wanted. Six photographs would be put up on the wall and one was chosen. The light was always on the model's right, and her eyes were looking toward it, to draw the viewer to the type. A psycho-analyst called Doc looked at the covers and if he didn't like one it just didn't go on.

Somehow, although Penelope Tree was fantastic, I never quite came to terms with photographing her because Avedon got to her first. Actually, Penelope's first professional photograph was done when she was 13, by Diane Arbus. Her father was extremely rich and powerful and he told Diane Arbus that if she ever published the picture he'd sue her ass off. Penelope's second photograph was taken when she was 15, by Guy Bourdin for MADEMOISELLE. At 15, she was as sophisticated as a woman of 35. She grew up having tea with Truman Capote, one of her best friends.

The photograph of CATHERINE DENEUVE was taken in 1968, when she was 21. At that point, I did fashion portraits of film stars like Racquel Welch, Julie Christie, and Catherine, which always was difficult. This is one of the best pictures I did of Deneuve, but VOGUE didn't like it for some unknown reason.

In those days, being a professional meant I only took out my camera when someone paid me. I wouldn't think of taking a picture for myself. If an advertising agency called me up to do a picture, I wouldn't argue about how to do it. I'd say, "Well, I don't think you're quite right," and just do what they wanted.

Today, there's a different attitude, influenced by the school of photographers who make a living taking pictures for themselves. I don't use a client's money to take my pictures. A fashion photographer sells frocks. If not he's cheating the client and him-self because he should be out in the streets doing what Don McCullin or Judy Dater does.

In 1970, I made the photograph of JEAN IN THE PYRAMIDS for English VOGUE, with a red filter on a Nikon, and Tri-X. The desert was white, so I thought a black sky would be nice, but Jean's look was more important than the technique. Part of the mystique of this picture involved hiring horses and riding out to

the desert together. Jean's horse dropped dead the next day but I never had the guts to tell her.

Elton John's "Sweet Painted Lady" inspired MARIE ON THE PIER, taken in Tahiti, in 1973. It's one of my favorite pictures because Marie Helvin becomes every lonely girl with a beautiful ass, waiting for her boat to come. A mysterious figure, she's part whore, part "French Lieutenant's Woman," the John Fowles character.

ITALIAN VOGUE was the only VOGUE that would use me then. I shot this photograph with an Olympus and a 24mm lens. A red filter and Pan-X rated ASA 25 gave me the contrasty quality.

On location, I take an incident light reading with my Weston Master 4. I don't understand the zone system or spot meters because when a reading is taken off the dark, light and grey areas, it comes out identical to the incident reading anyway. In the studio, I just shoot a Polaroid rated at ASA 65 instead of 75, and add one stop for FP-4, 1½ or 2½ stops for Tri-X.

MARIE IN THE PLASTIC RAINCOAT was done for FRENCH VOGUE to illustrate the watch in the pocket. Guy Bourdin, Helmut Newton, Sarah Moon and I were given six pages each to photograph a shoe, a dress, a watch, and a few other things, however we pleased.

It's nice when there's time to explore the possibilities of objects and ideas. Sometimes, I fly to Milan on a Monday morning and walk into the big, white box VOGUE calls a studio, and the editor points to 40 dresses hanging on a rack and says, "By Thursday, Bailey, I want those photographed." I usually act temperamental because the Italians like artists and it's a way to stall for time. I say, "Oh, I can't do the picture without a bottle of cognac and 20 mirrors." While the editor's out, I try to decide what to do with them. Fashion is a bitchy business. I can be charming, but if the pictures don't work, darling, I'm not going to last long. "You're only as good as your last set of pictures."

MARIE IN THE ST. LAURENT BATHING SUIT was shot in the Yucatan in evening light. On location, I never shoot before 4:00. Only mad dogs and Helmut Newton go out in the midday sun with a camera. This exposure was made on FP-4 with an Olympus and a 135mm lens.

Fashion, in black and white, can be shot in the morning, but I never begin a beauty shooting before 1:00 in the afternoon. At 9:00 AM, girls are puffy from having been at it all night long. I prefer doing fashion and beauty in the studio because the light and heat can be controlled. Between September and April, I don't work on location because I don't believe in getting pneumonia to take a picture. Besides, girls with goose pimples don't look sexy.

The slightly raunchy photograph of MARIE IN THE LEOPARD SKIN

was shot for RITZ, the newspaper I started when ENGLISH VOGUE wouldn't use me any more. An editor of VOGUE said I make all girls look like whores. But I try to make them elegant—slightly beyond a man's wallet and his sexual desires.

The white dress in THE WEDDING PHOTOGRAPH satirizes the symbolic purity of a white dress. It's like a nun's habit with the pussy showing through. No girl is a virgin anymore, unless there's something wrong with her. I wanted to show how ridiculous and pagan a girl in white is, when she's obviously been at it for years.

Both THE WEDDING PHOTOGRAPH and THE HORIZONTAL NUDE OF MARIE were made with an Olympus and a ring light. The ring light eliminates shadows, except for the fine black line around the figure. Since 1961, I've used this adaptation, by Clifford Coffin, of a light dentists use to photograph inside mouths.

My original ring light was incandescent. I got terrible burns on my forehead from looking through the fucking thing. When the strobe ring light came along, it took me ages to figure out how to get rid of the red eye. When I discovered it's a reflection of the blood in the eye, I put a spotlight on it to close down the pupil and used a long lens at 1/125th of a second.

Clifford Coffin had a homosexual view of women as untouchably elegant. The best fashion photographs have a homosexual attitude that's something remembered from one's mother. A photographer doesn't necessarily have to be a homosexual to idealize women. For example, Beaton, and Von Sternberg had homosexual attitudes, while certain photographers I won't mention see women as dirty. The heterosexual view is if she's got her period, she's useless.

When I made THE NUDE OF MARIE, we'd been married about four years. The geezer upstairs stamps out a perfect body every now and then and Marie's is the closest I've come to perfection. This photograph is so straightforward, it's almost a passport picture. All I did was put a bit of wind on it. The ring light hides nothing. What's there is there.

MARIE AND THE MAN IN BLACK was shot in the studio with a 6 x 7 Pentax. When I made this photograph, I wanted to get the look of the 20's fashion illustrations in which everyone looks eight feet tall. The only way I could do it was to cut the picture in half at the knees and put a strip of black in. Later, through my involvement in cinema, I discovered the anamorphic lens. It's used to stretch out type for the credit titles, but it can be used vertically as well. MARIE could be shot with the anamorphic lens because she has a long neck and sharp features. It doesn't work if the girl has a round face.

The PRE-RAPHAELITE PORTRAIT was influenced by Rosetti's

paintings. I was mad about frizzy hair and a white face until it became trendy. I liked working with the contrast between an out-moded, overstated Victorian look and a modern, scientific technique—infra-red film. In winter I rate it ASA 125. In summer it's ASA 400. The film must be loaded in the camera in a changing bag, I develop it in D-76.

When I first started photographing I didn't know what I was doing. I took good pictures by instinct. Now I work by intellect. It took me 25 years to understand photography, and yet I'll never know everything. I've never really learned how to print well. All my professional printing is done by someone else, but I've started printing as a hobby, in order to understand light better. To me, photography is magic because you never come to the end of it. The more you do it, the greater the challenge.

My greatest pleasure comes from looking at other photographers' pictures. It's exciting to discover a new photographer, like Sudek, for example. Subconsciously, I'm influenced by him because his pictures stick in my mind. The majority of fashion photographed today is shit. It was more inspiring in the '50's and '60's when Avedon and Penn were still exploring. Now the only people still growing are Helmut Newton and Guy Bourdin.

At last count, I had sixty cameras after I got rid of some. Many of them were gifts that I've enjoyed experimenting with, but they haven't improved my pictures. I like to see how models react to different cameras but, in fact, I'd probably be a better photographer if I'd stick to one format.

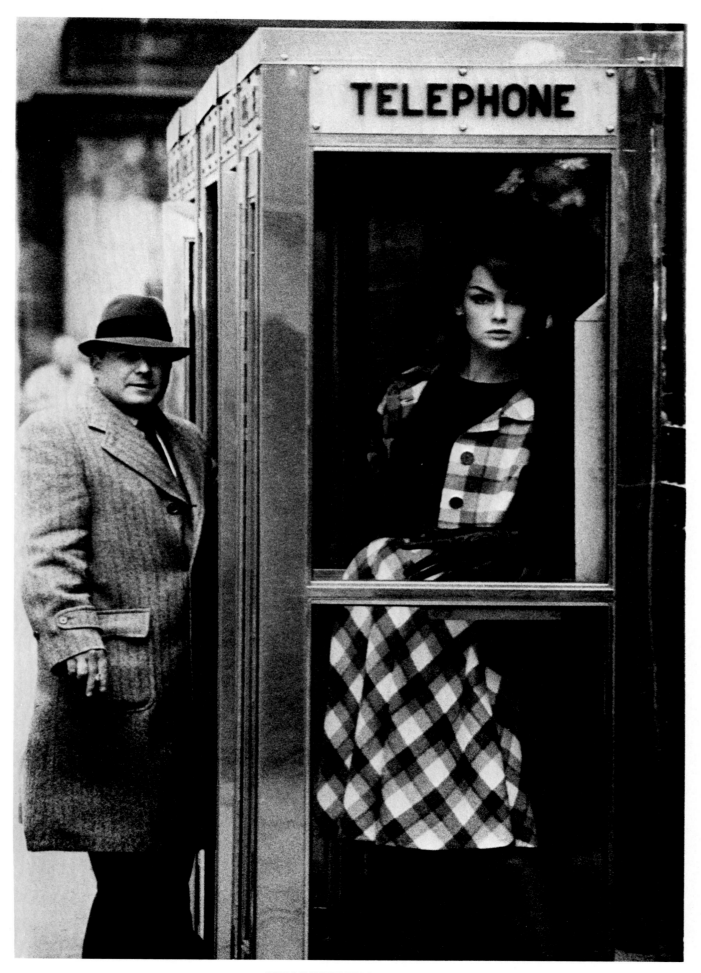

JEAN IN THE PHONE BOX

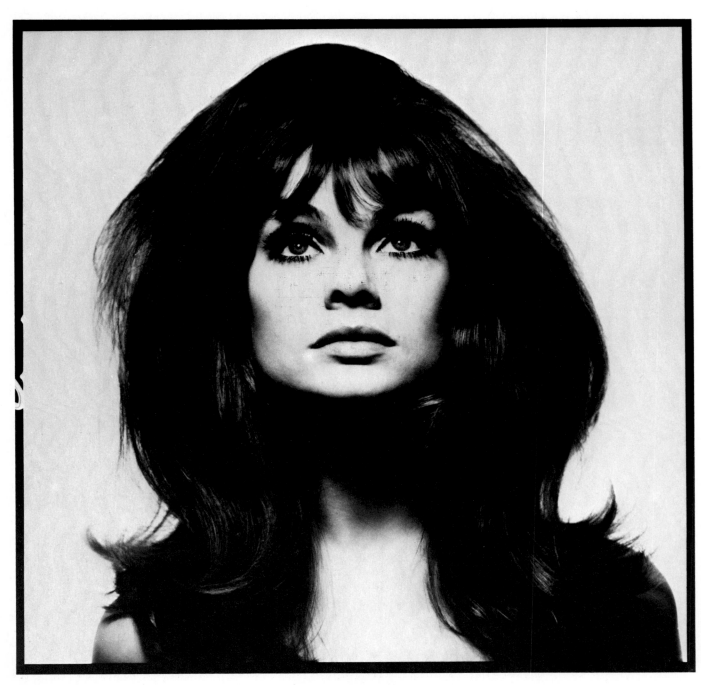

JEAN WITH THE WILD HAIR

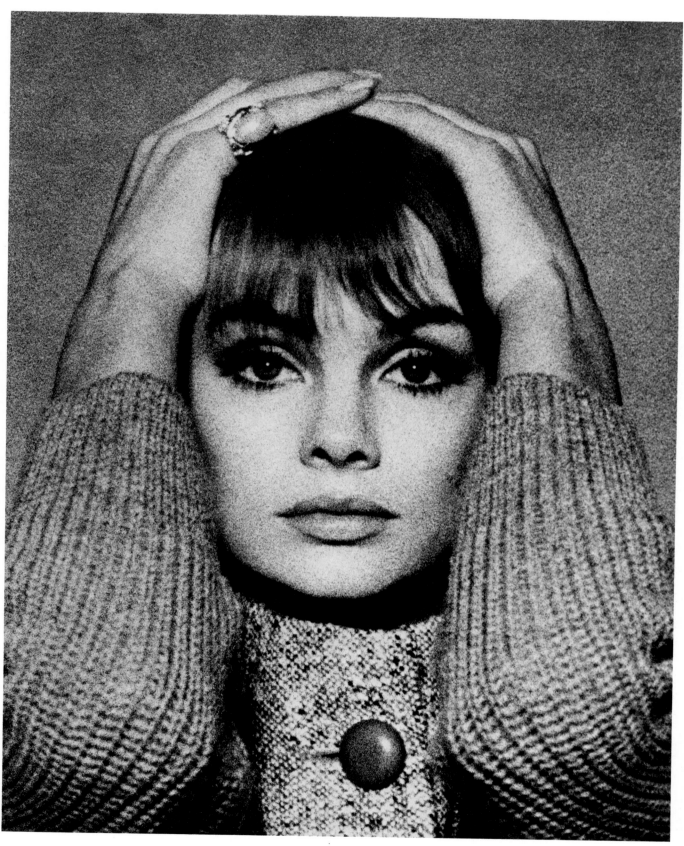

SHRIMPTON WITH HANDS AND HAIR

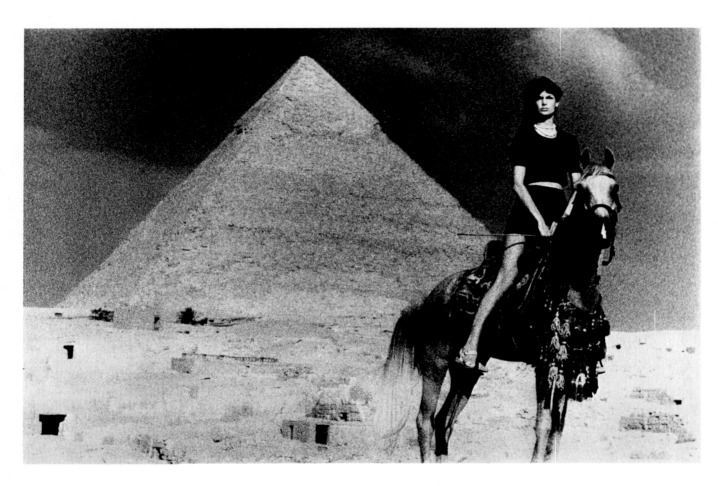

JEAN IN THE PYRAMIDS

CATHERINE DENEUVE

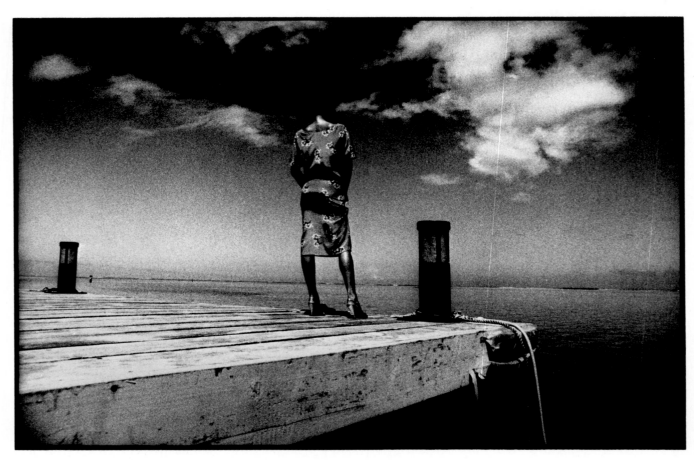

MARIE ON THE PIER

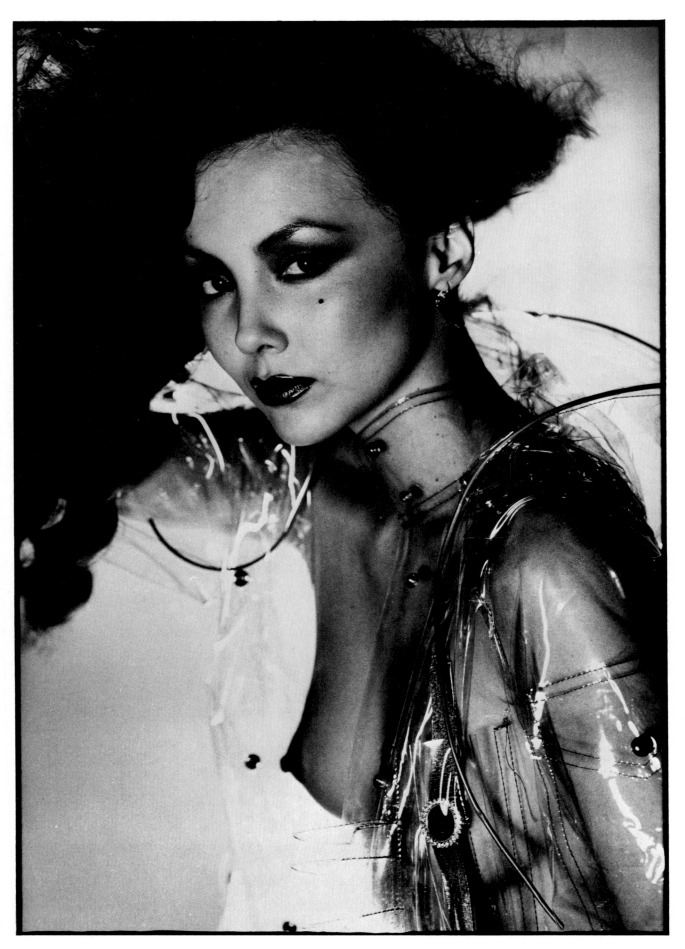

MARIE IN THE PLASTIC RAINCOAT

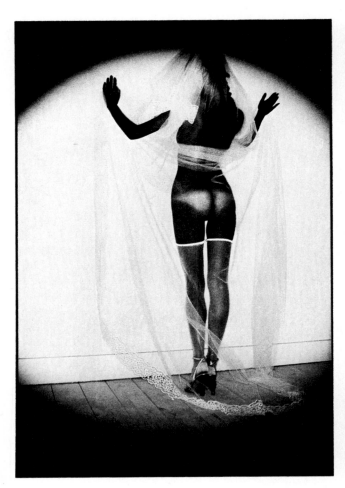 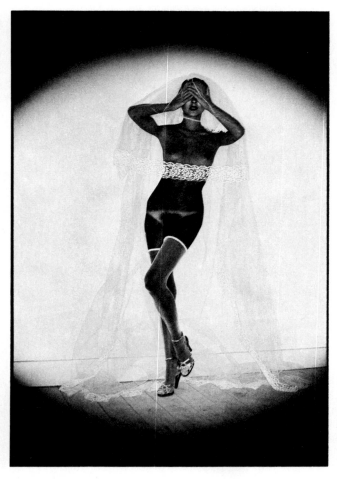

THE WEDDING PHOTOGRAPH

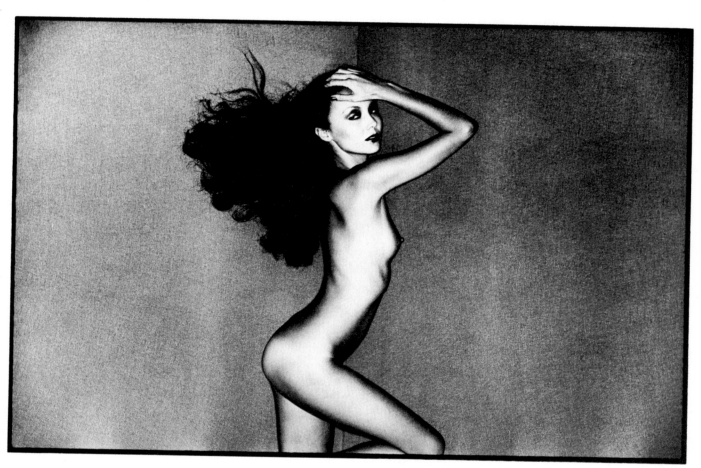

THE HORIZONTAL NUDE OF MARIE

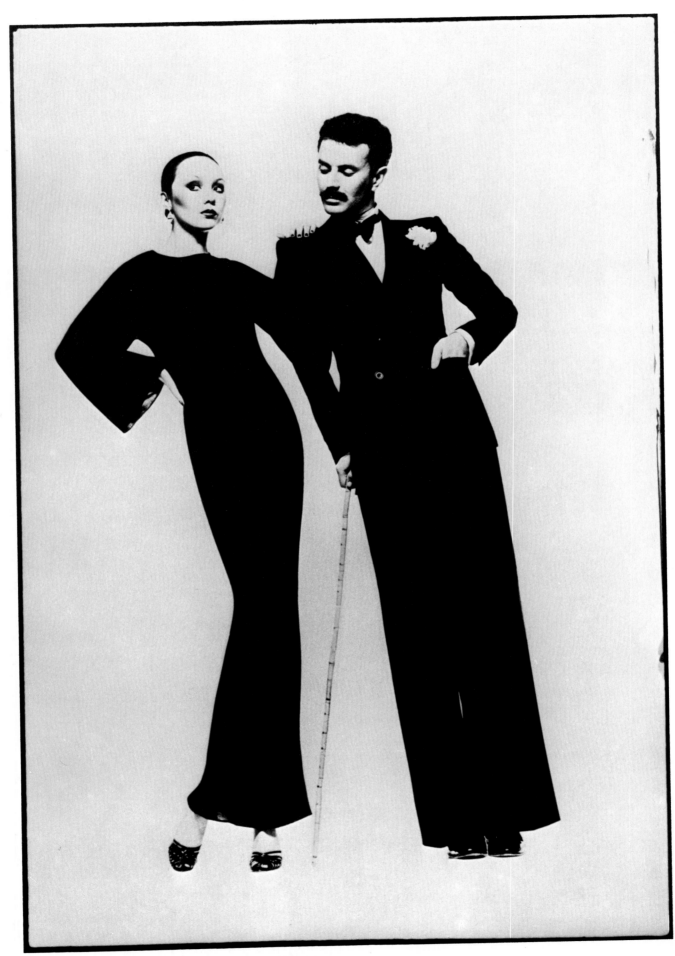

MARIE AND THE MAN IN BLACK

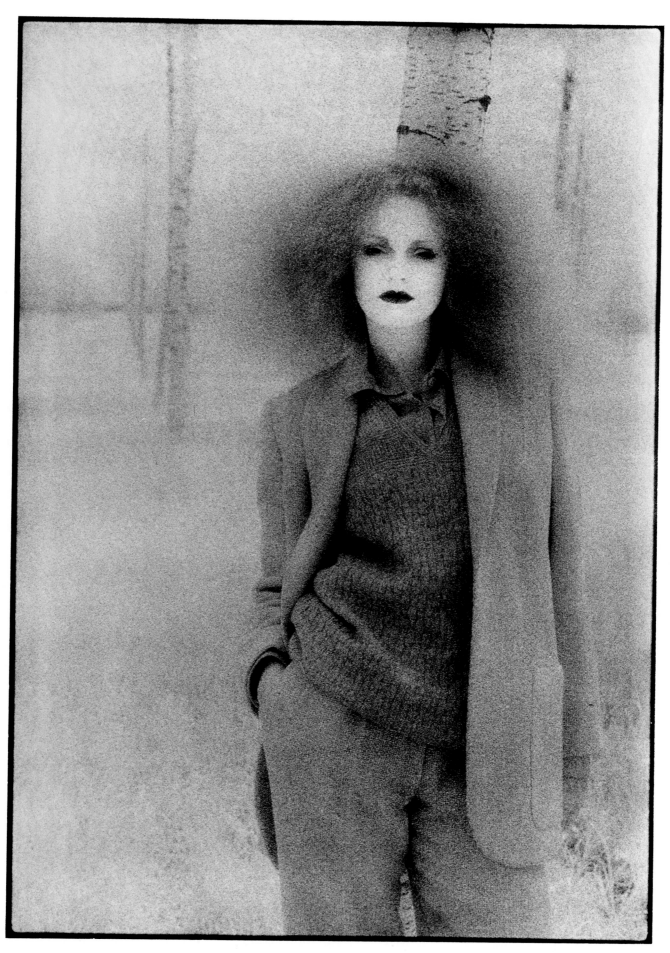

PRE-RAPHAELITE PORTRAIT

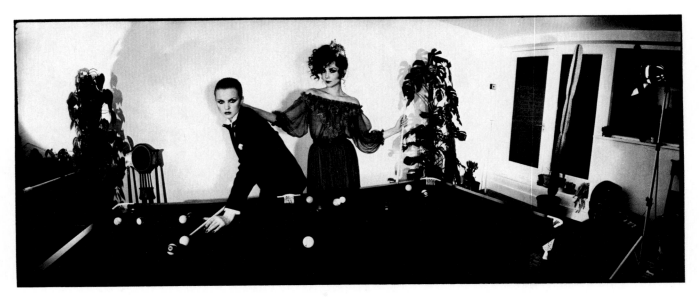

UNTITLED

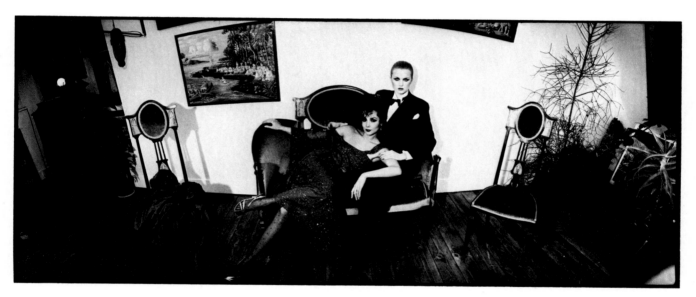

UNTITLED

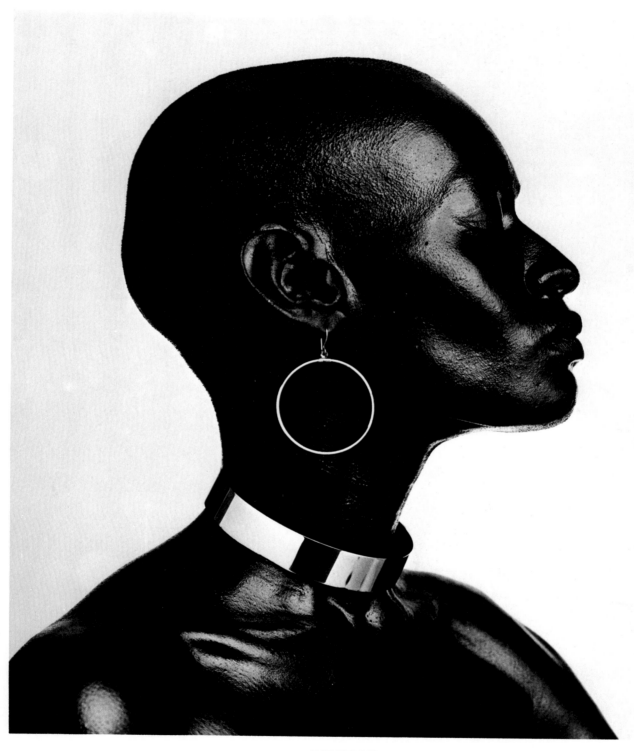

PAT EVANS

"I photograph girls whose looks I'm attracted to, and whom I like as people."
ANTHONY BARBOZA

I decided to photograph fashion after getting out of the service in 1970. I met a girl named Pat Evans, liked her looks and we started testing. One day she came into the studio and said she wanted to cut her hair. I didn't think she should but she did it anyway. A new cosmetic for black women, called Astarte, was being introduced by the Spectrum Cosmetic Company and Herb Lubalin was designing the first ad. Pat went to see him with some photographs I'd taken of her. He liked her look with a bald head and hired us to do the ad with her in profile. After I shot a portrait of her with regular makeup—natural medium brown, we painted her with jet black cake makeup and did this shot that the client never saw. The bald head was shocking enough. When ESSENCE first came out, this ad caused such a sensation that people came from all over the world to take pictures and do stories on us. I thought it was silly, but then after that, Rudi Gernreich showed his bald Unisex twins and the look was in for a while.

This photograph was made in 1971 with a Hasselblad on Tri-X. I bounced two strobes off a solid white background to give definition and separation to the profile. A white card reflector was used to highlight the necklace, and a strobe shot through an umbrella illuminated her face. I'd rather shoot in sunlight when I have the time. It generates more creative possibilities the way it defines objects and constantly changes. When I use strobe, I create the mood through the way I light.

My beginning was as a street photographer working in the style of Cartier-Bresson. I came to New York in 1963 after getting out of high school in New Bedford, Massachusetts. After working as a messenger for the Hearst magazines during the day, I'd print at night for Hugh Bell. Then I got drafted and worked as a photographer in the service. When I got out I couldn't decide whether to go into advertising or journalism to support my own photography. I had to make money and, since LIFE and LOOK were dying, I went into fashion. I started doing reportage fashion, shooting girls walking down the street with a wide angle lens. The clothes were obviously secondary and the editors I went to see said the pictures were too "arty." HARPER'S BAZAAR was still running graphic pictures of dresses shot in the studio and outside. My reportage wasn't commercial enough. Then in 1970, BAZAAR let me work for them, doing the little pictures in the back pages. For two years they paid me $125 a month for 14 pictures. When I started complaining that I didn't want to do that anymore, they broke me into the middle pages. I shot maybe four assignments for Ruth Ansel before she quit in 1973. The guy who replaced her as art director came from TOWN AND COUNTRY and never used black photographers. There was ESSENCE, but it was only one

magazine with a lot of black photographers fighting to work there.

In fashion, the money is good and the women are fantastic, but as I get older I just want to do my work. It doesn't matter if I'm shooting fashion or portraits because I do it the way I see it. I love photography and that's always been most important. Some of my fashion photographs have hit a high note for me, but I usually do a job for money because if I get paid enough in advertising, I can do my work the way I want it. I buy the film and make the decisions.

My life is totally integrated into my work. The pictures I take, the books I read, the music I listen to, the food I eat—they're all part of the art form. Jazz musicians such as Ornette Coleman, Charlie Parker, Coltrane and Cecil Taylor inspire me. I read Octavio Paz, Jorge Luis Borges and Italo Calvino and fill my life with what makes me feel good, in order to transcend the frustrations of the business. My ideas come from many places. To bring up fashion ideas I look through hundreds of magazines. I might see a shape or an object that will suggest a scenario, and write it down. I don't plan too much and allow myself to be open to everything. I try to stay fresh and spontaneous because ideas become limp and die if they're too premediated.

In 1975, I shot an ad for Dimitri, a tailor who designs for men and women, of THREE FIGURES BY A POOL. He let me do what I wanted to do. I didn't preconceive it as I had my early sequential pictures. The guy in a bathing suit and two girls by the pool didn't really know what they were supposed to do, but got into their things and began to act. I thought that when people go to a pool, they pose and parade around in their newest bathing suits. They put on their sunglasses and perform as if they're in a movie. For some freak reason, I don't remember how it came about, I had my assistant waving this shirt, like a flag calling time out. React and wake up. I took the photograph and somehow the introduction of myself, through the shirt, caught all the ideas I had about fashion. After four years of shooting reportage, this was my peak.

After this photograph came out in ESQUIRE and GQ, I got jobs for which I could create and design the total concept. I call it my million dollar photograph because it led to my getting the Abraham and Strauss newspaper account. I was so broke before the Dimitri shot that I had to bulk roll the film, which made scratches that were retouched. Someone bankrolled it and then I made more money than I'd ever seen in my life. I worked day and night five days a week, spent the money and had a good time. Then I lost the account because they were spending too much money and went in-house.

THREE FIGURES BY A POOL was shot through a Hasselblad DF-2 diffusion disc on a 35mm lens on a Nikon. When I do a job, I'm not sure what lens I'll use until I see the location and position of the models. I prefer a reflex camera because I can see through the lens and frame exactly. I use a Leica rangefinder only for my own work on the street. This was shot on Tri-X.

When I started working for Abraham and Strauss, I had to figure out how to shoot 20 ads in a day. Altogether I did 500-600 ads for them and 99% were with a ring light, a strobe that fits around the barrel of the lens for a reportage style of quick shooting. When I went on location and shot in different rooms of an apartment, I wouldn't have to take time to set up lights for each photograph. I liked the shadowless effect with a slight outline, which came into vogue about that time.

Since every job was a rush for daily ads, A & S allowed me to be creative, and shoot what I wanted, and edit the take each day. I shot everything—fashion, lingerie, jewelry—with straight and more playful ideas. THE GIRL WITH THE MASK and THE GIRL WITH THE MIRROR were shot in the same day, but they didn't use either one. They'd give me 25 sets of lingerie to photograph in a day, out of which maybe 10 would be chosen as full-page ads, several as half and quarter page ads, and some smaller ones. I'd shoot all day and work with my printer until three in the morning. He'd develop and contact print the negatives, I'd edit, and he'd make prints, all of which would be delivered the next morning. Sometimes they'd select something I didn't print and we'd run it through quickly. At that time, I had a full-time stylist, 3 assistants, one of whom was a high school intern, a night printer, and my brother who reps me.

The BLURRED SHOT is another out take from an A & S job. I use this technique fairly often and they liked it, but felt the ink would block up in reproduction and the detail in the clothes would be lost. I used a mixture of ring light and photofloods and used a shutter speed of ½ second. The strobe catches the sharp image and, as the diaphragm of the camera stays open, the flood picks up the motion as a blur. I use this in my portfolio because the technique seems to get work from advertising agencies.

I test to work on ideas for clients. Also, when I get an idea for a photograph, I have an urgent need to get it out of my mind and on paper. I used to do test after test with many girls every day. Now I get an idea and try to follow through with background and props, to make sure everything is coordinated and not a waste of time and money. There must be a stylist who can get the best clothes, somebody to do props, a hair stylist and makeup artist. Testing is expensive but the photograph won't be good

unless there are professional people behind it. I use the money from my advertising jobs to test. It's a business expense.

The test for an AD FOR THE CHELSEA COBBLER was put together by a freelance art director and I. We wanted the boot to be sexy so instead of shooting on the street, we put a girl in a satin sheet with nothing on but one boot. I shot from a ladder with a ring light to give the effect of a cutout with an outline. It was shot in color and black and white.

A photographer's most important contact is with the model. I constantly test with five girls who cover a range of types for the business: blonde hair and blue eyes, dark hair and eyes, a black girl who looks the way most people think black girls look. I've had problems with clients who've said a black girl I've wanted to use didn't look black. If there's a mixture of features, they won't use her. Most people in this country don't realize that black people range in color and features.

I photograph girls whose looks I'm attracted to, and whom I like as people.

Not only must I be attracted to the girl, but the clothes as well. If I don't like the clothes, I can't get a feeling for a photograph, and just doing it for money, the shooting will be a flop. Fashion can be an art form when the garment is exciting and the girl turns me on. Then everything flows.

I prefer a model to look directly into the lens. Contact and interplay between myself and the model makes a better picture. In a portrait of a fashion model, there is a certain look in the eye I always seem to select. The WOMAN WITH THE FEATHER BOA was a fashion test and a portrait at the same time. On a test, I can do things I often don't get a chance to do on jobs, because I do more advertising than editorial assignments. This picture was shot with a diffusion disc taped on a 105mm lens on a Nikon, and one direct strobe on the model. I pushed Tri-X to 800 to increase grain.

I tried to treat the Avon Fragrance ad of A MAN AND WOMAN IN A ROLLS ROYCE as reportage. Natural light was bounced off white reflectors through the back window, which I covered with tissue paper to soften the light. This photograph was diffused and printed on Kodalith paper, which I used for fashion at one time.

A beauty photograph is essentially a head shot, tightly cropped from the top of the head to the neck. Its purpose is to show makeup on the face. When I do an advertising shot, the art director will describe exactly how tight the shot should be from the layout. For an editorial photograph, there's a little leeway but not much. As a rule, I never crop my own photographs as tightly as the beauty shot of REIKO, Japan's top fashion model, taken when she was in New York. Nor do I use a long lens for my

work. For my commercial photographs I use a 120mm or 150mm lens on a Hasselblad or, for this shot, a 105mm lens on a Nikon. This is Plux-X rated at 320 and developed in Acufine. I used one Balcar strobe bounced into an umbrella from the left and a white seamless background. I use a plain seamless only for my commercial jobs. Girls look lost against it.

I get a little crazy if I don't do something for my own satisfaction, something entirely different from fashion, yet influenced by it. Since 1975, I've been working on a series of portraits in 2¼ format, in black and white and color, with space around the subject. When I shoot, I move in for a closeup and back for a full length on the same roll of film, which someone once told me was strange.

I recently began making my own backgrounds by cutting and painting seamless, which allows me to say more about my subjects, to interpret them for that moment. I've also been photographing jazz musicians in color, in 8 x 10 format, on location. There is a definite inter-relationship between portraiture and fashion and ideas from both are incorporated into my work.

I wanted to make a PORTRAIT OF ANITA RUSSELL NUDE because she is a model always photographed in fashionable clothes. This picture was made last year and appeared in PICTURE MAGAZINE. The background for the PORTRAIT OF DENESSA TOBIN was designed for the dancer's personality. I stapled colored papers on the wall, the way little cutout feet are put on the floor at dancing school to show the steps. I asked Denessa to make this movement, and selected the shot because it reflects who she is to me. I work spontaneously and don't really think about these things when I'm doing them. I just have my method and follow it.

When I photographed the PUNK GIRLS, I wanted something with dramatic appeal. They were wearing black so I used white tape on black seamless paper for a design with starkness and movement. Another fusion of fashion and portraiture is the picture of TOUKIE SMITH, Willie Smith's sister. She had on a gold outfit by Issei Miyake, took off the top and put her hands over her breasts. I had cut lines in black paper and spray-painted it gold to be an extension of the dress. Toukie is like a flower in the forest. I tried to recreate my feelings about her as we talked and shared the time. If I were to shoot another portrait of her tomorrow, my feelings about her would probably be different and so would the portrait.

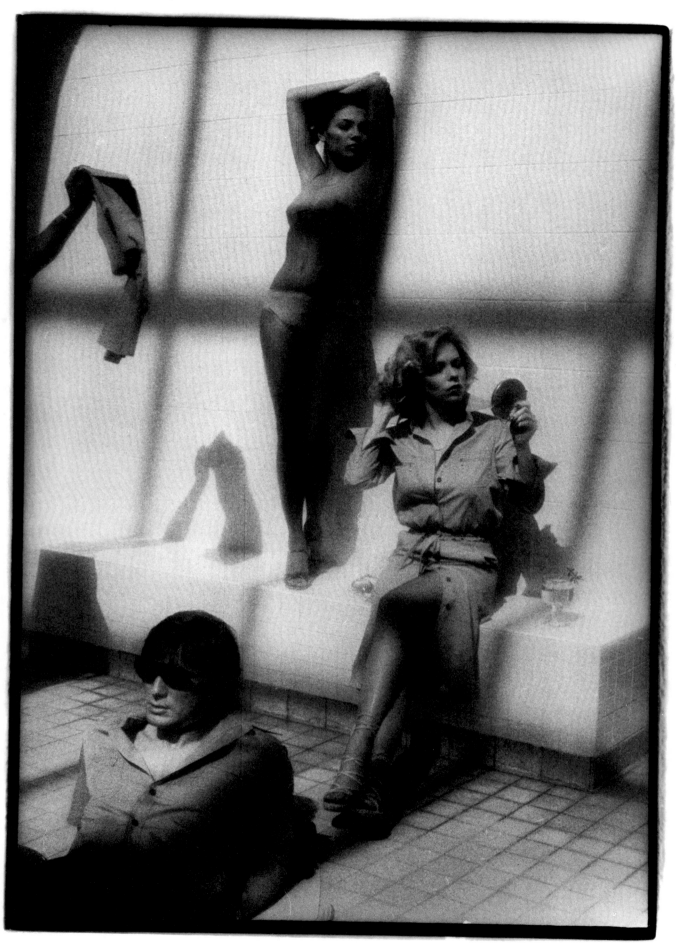

THREE FIGURES BY A POOL

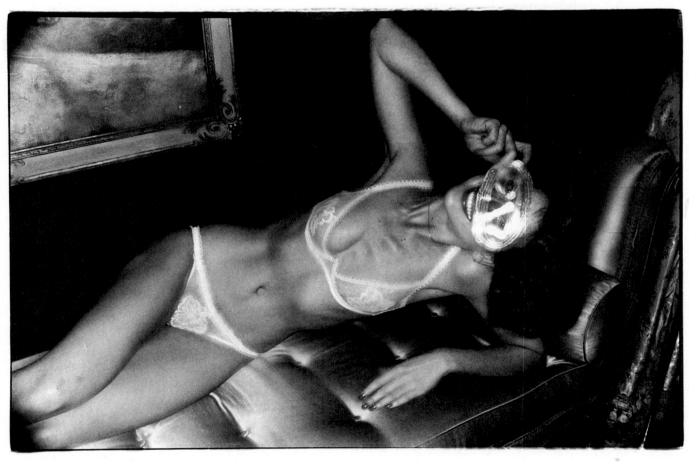

THE GIRL WITH THE MASK

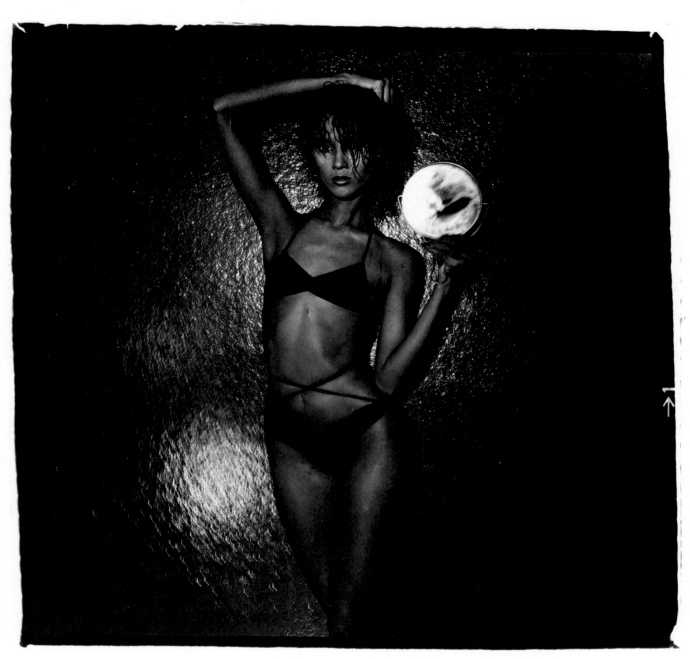

THE GIRL WITH THE MIRROR

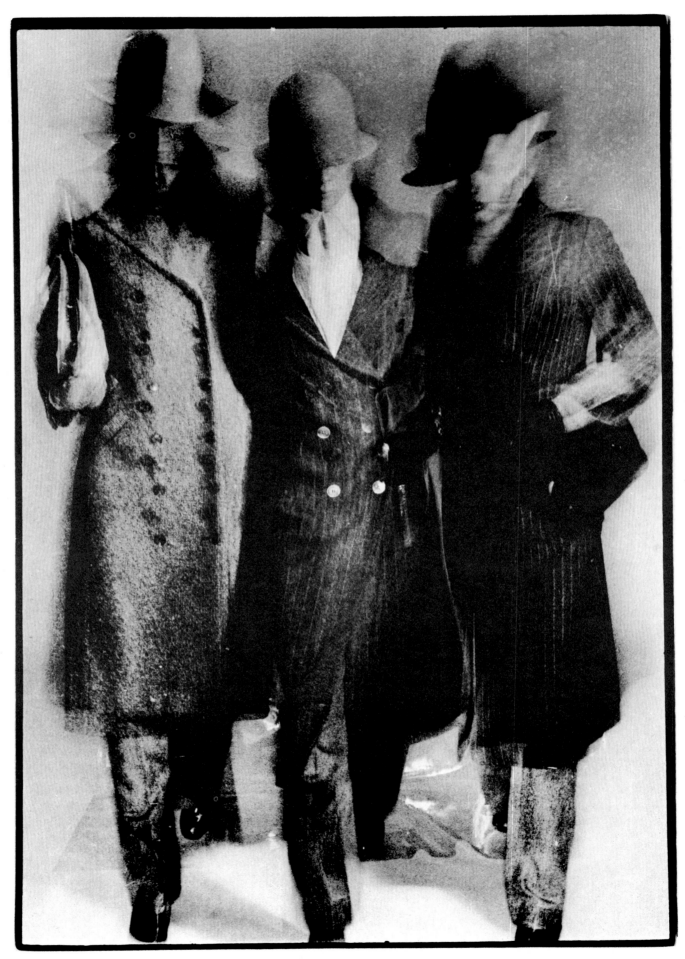

BLURRED SHOT

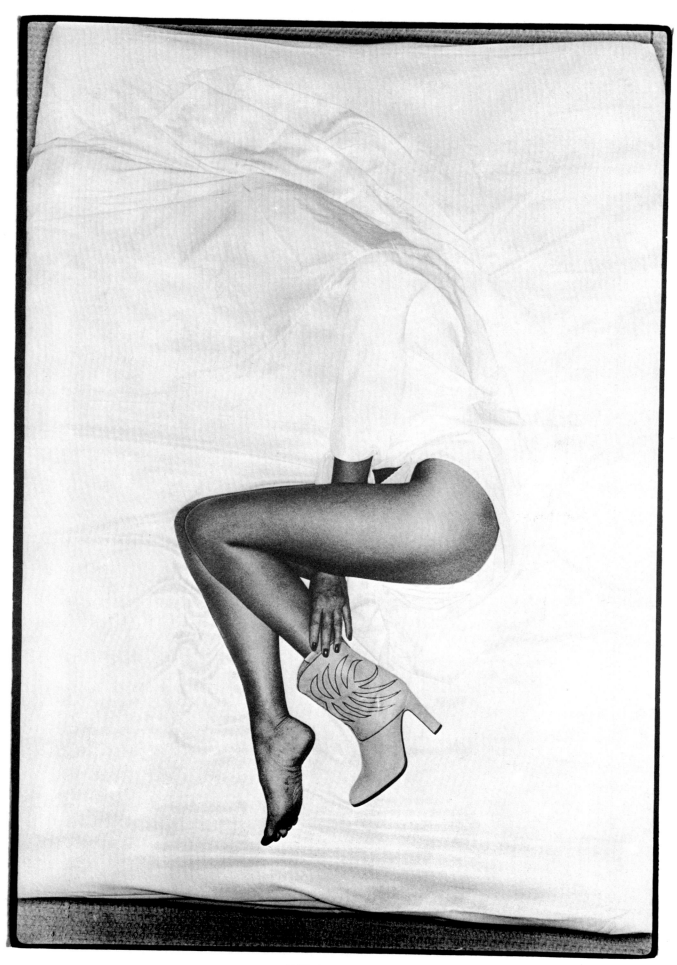

CHELSEA COBBLER

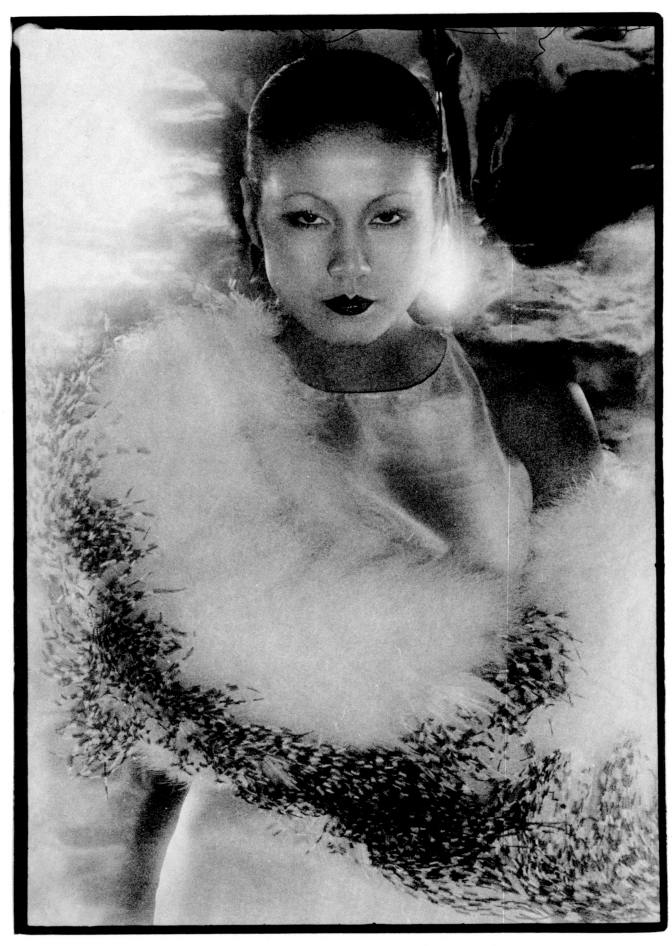

THE WOMAN WITH THE FEATHER BOA

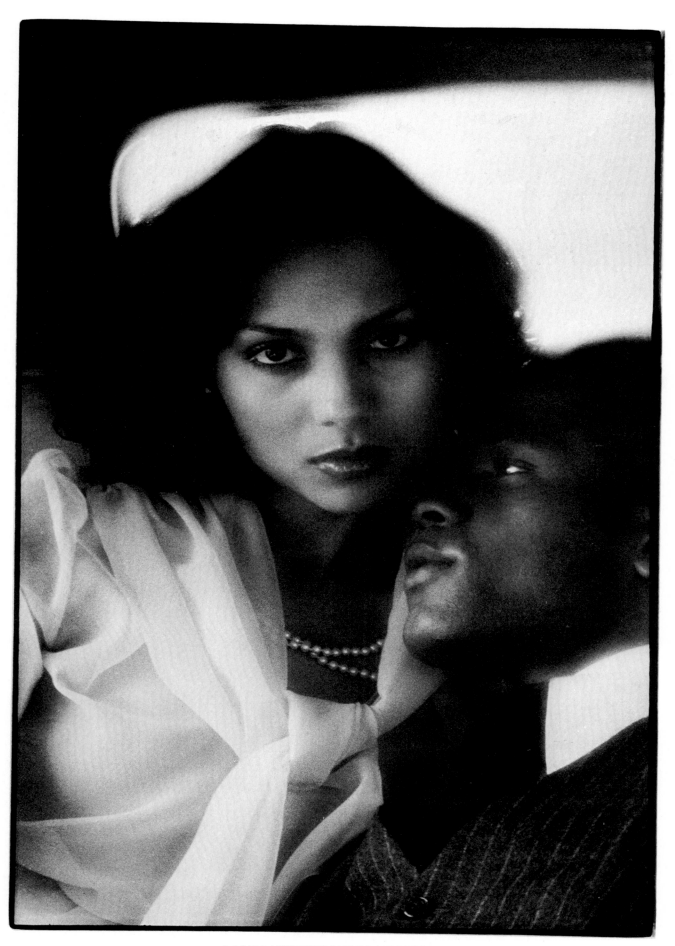

A MAN AND WOMAN IN A ROLLS ROYCE

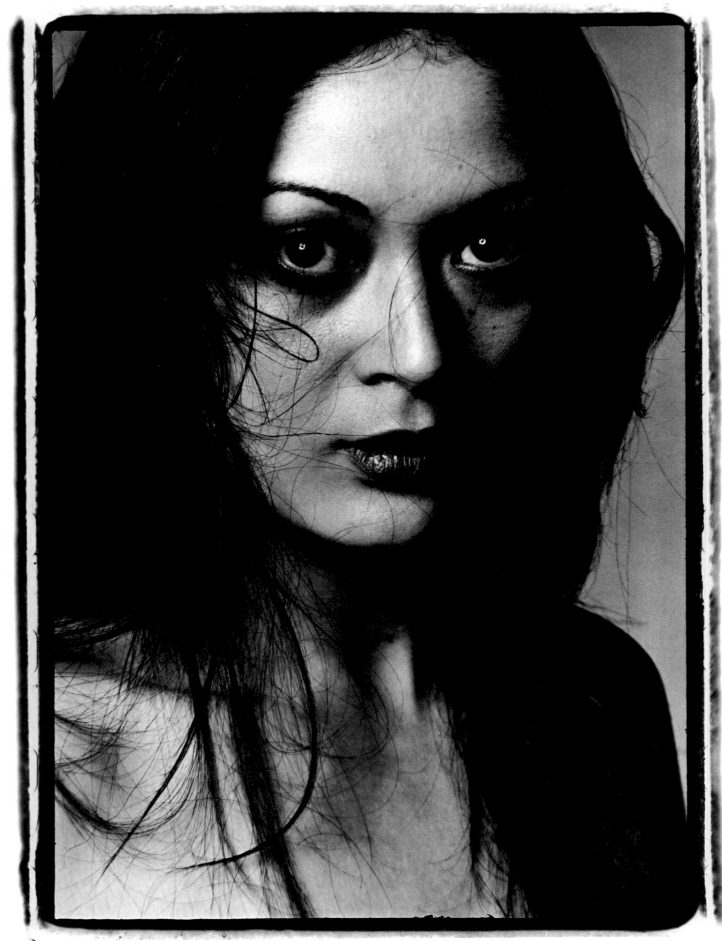

REIKO

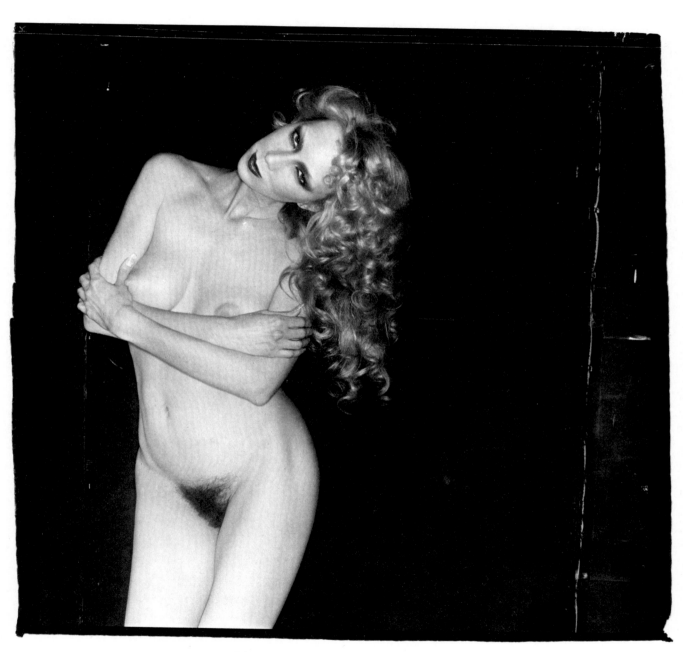

PORTRAIT OF ANITA RUSSELL, NUDE

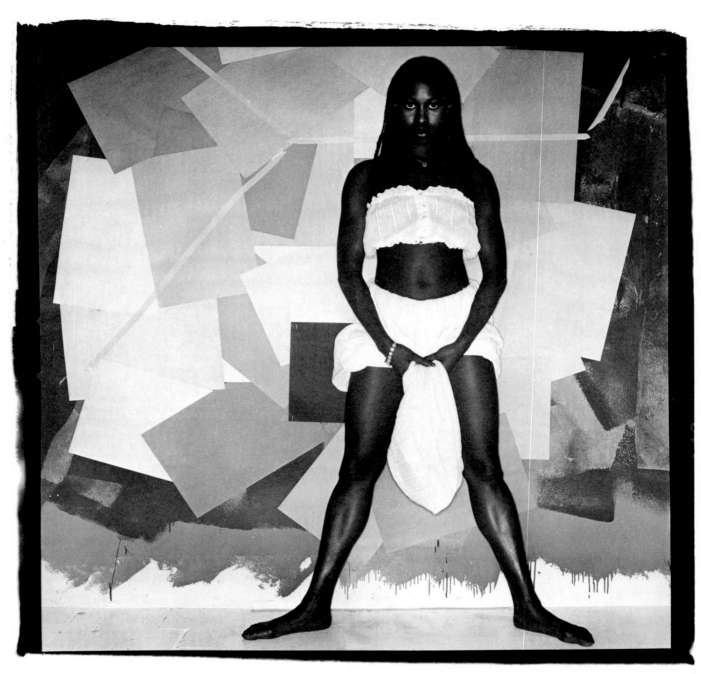

PORTRAIT OF DENESSA TOBIN

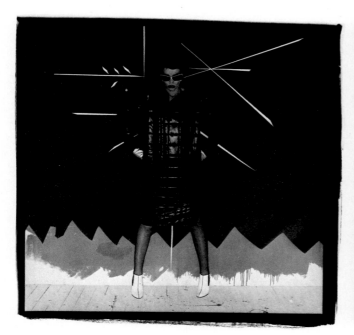 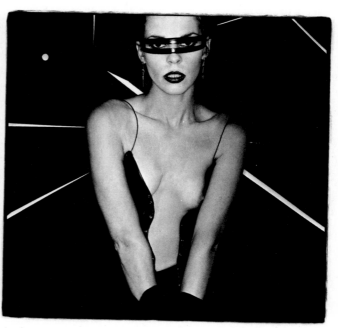

PUNK GIRLS

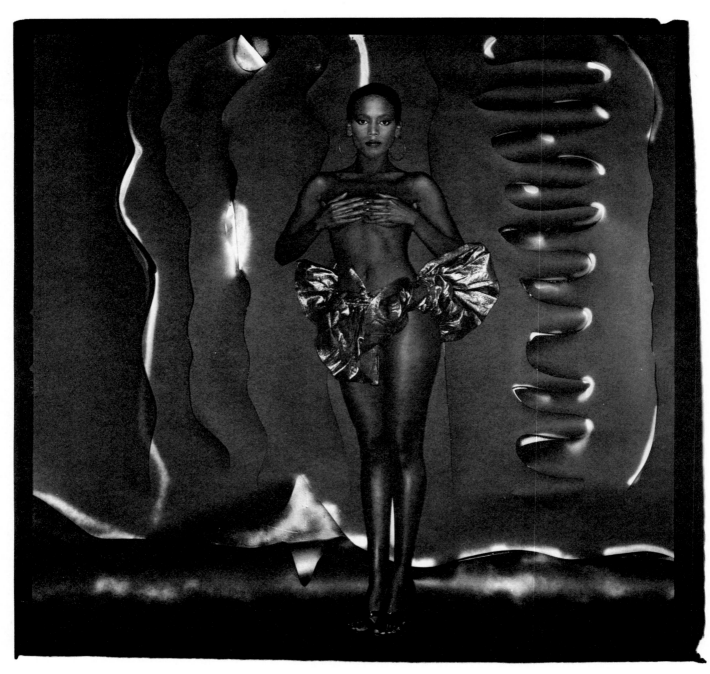

TOUKIE SMITH

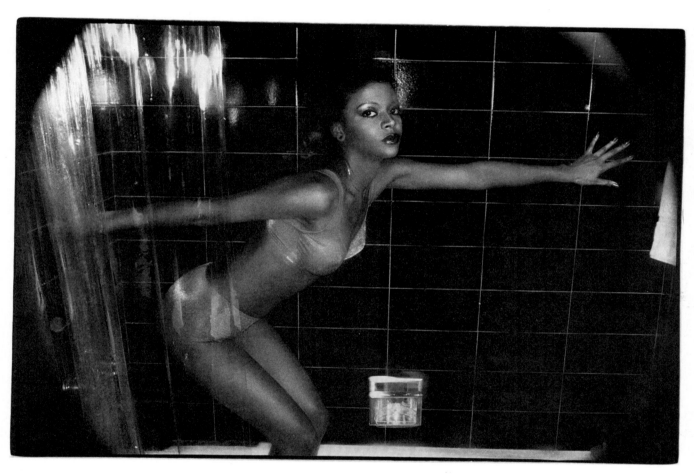

UNTITLED

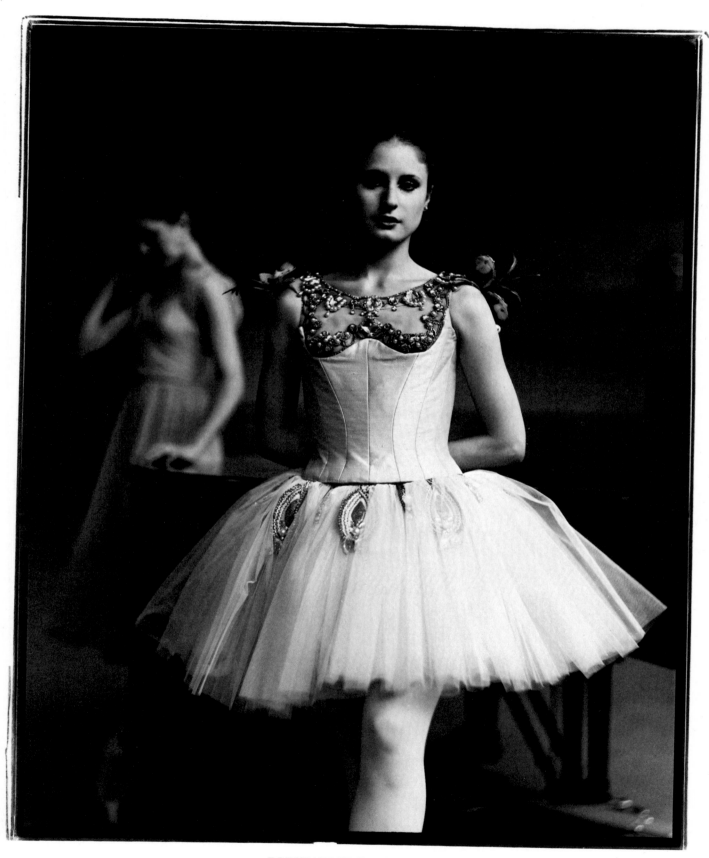

PORTRAIT OF CAROL DIVET

"When taking a photograph feels right, it's like falling in love." ARTHUR ELGORT

Ballet made me aware of clothes and movement. Photographing on the street taught me about a person's style and confidence. When I first started working, I used models who were dancers and saw that if a girl breathes and focuses well, she will wear clothes well. A model should be aware and alive, look intelligent, poised and relaxed. It's an attitude that makes a good photograph, as if there were air moving through it.

I've always steered away from formal studio pictures. What I do best is see people being natural in good light. Instead of preconceiving a photograph, I want to get a variety of pictures. When taking a photograph feels right, it's like falling in love. I'm on the street and see a girl and want to keep looking at her.

Unconsciously, I try to show the clothes but ignore them as well because what's chosen by the magazine is not necessarily great. I try to work with models and stylists who can put clothes together in a way that would make you think they like them. Also, a model can overcome the clothes if she carries them well and knows how to break the space in them.

I started taking pictures of girls in 1963, when I was taking art courses at Hunter College and working as a waiter. I was making paintings and using mirrors to look at them and wanted to take fast pictures to see them removed one more time. I called up a sweet kid I knew from summer camp, named Stephen Shore. He told me to buy a Polaroid 100 because it was automatic and I didn't have to know anything. Before I knew it, I was less interested in painting than photographing the girls in the cafeteria or after school. It was more social than going to painting class, where I worked alone and never felt like a Rembrandt or Matisse.

I was getting paid from the minute I started taking photographs. I always took pictures for myself while doing a job for money.

Then I worked as an usher at Carnegie Hall where, during performances, I'd run up to Ballet Arts and take pictures of the dancers laying around between classes. Today, my series on the New York City Ballet (which started in 1978) is both a personal and commercial project. These pictures will appear in both book and souvenir program forms. They are a black and white series taken with a 4 x 5 Graphlex.

In the mid-sixties, I did darkroom work for Carl Fisher and then, through Jimmy Moore, I met Gus Peterson and became his assistant. One day he said, "If you could make fashion pictures that look like your dance pictures, you'd be a successful fashion photographer instead of working in people's darkrooms." I started testing, put a book together in the summer of 1968, and dropped it off at some magazines. My first assignment was a portrait of Clive

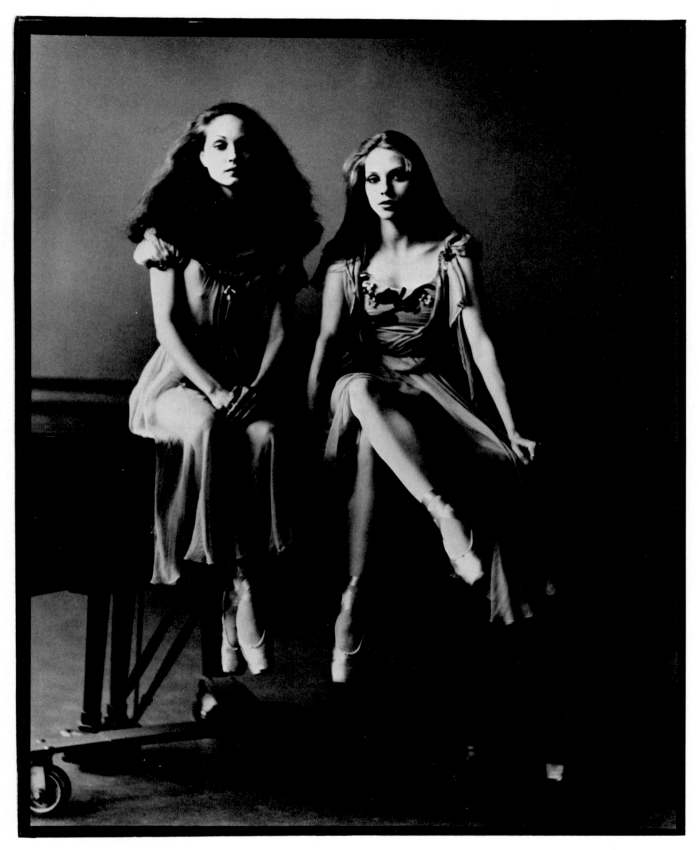

THE ROY SISTERS, LESLIE AND LINDY

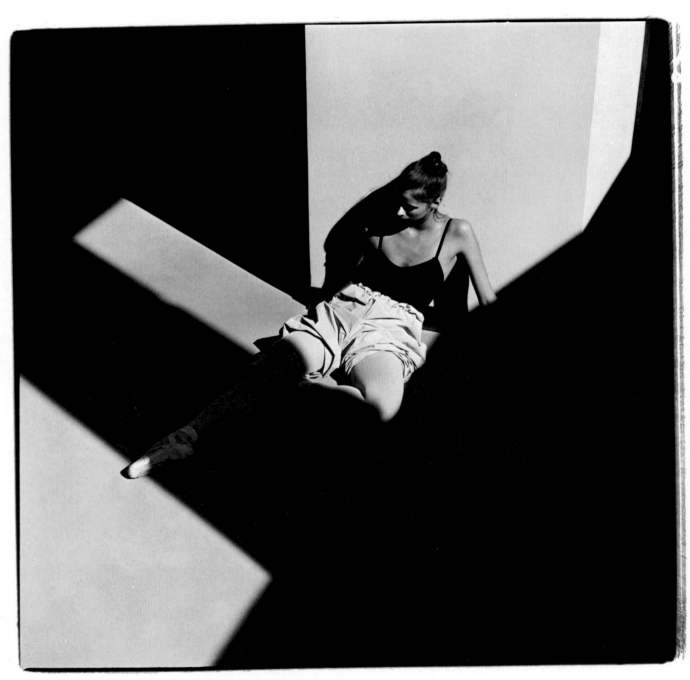

WILHELMINA FRANKFURT IN THE REHEARSAL STUDIO

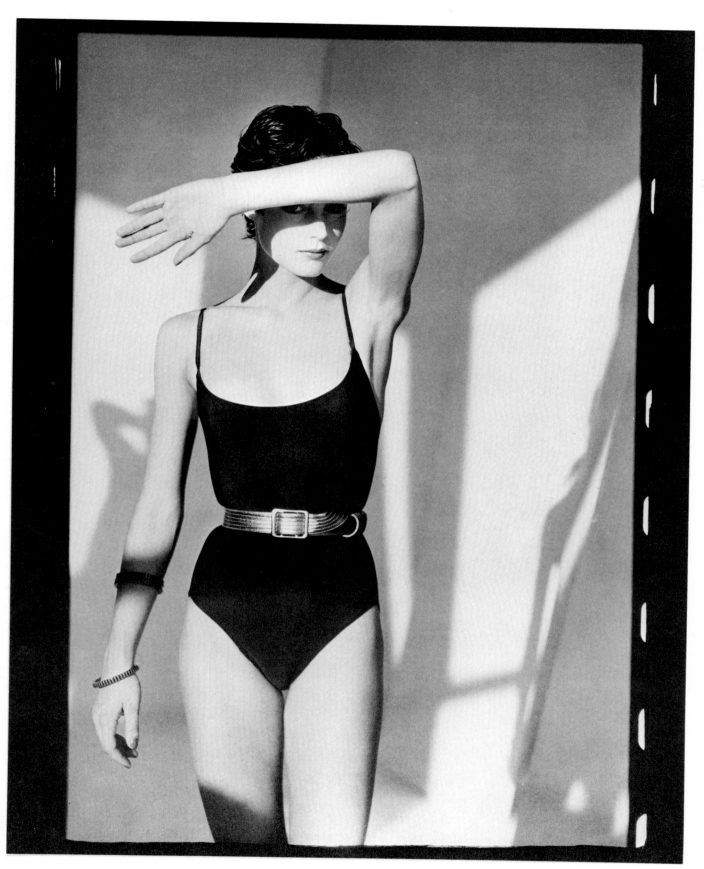

ESME MARSHALL IN A LEOTARD

CLOSE-UP OF MICHELLE STEVENS

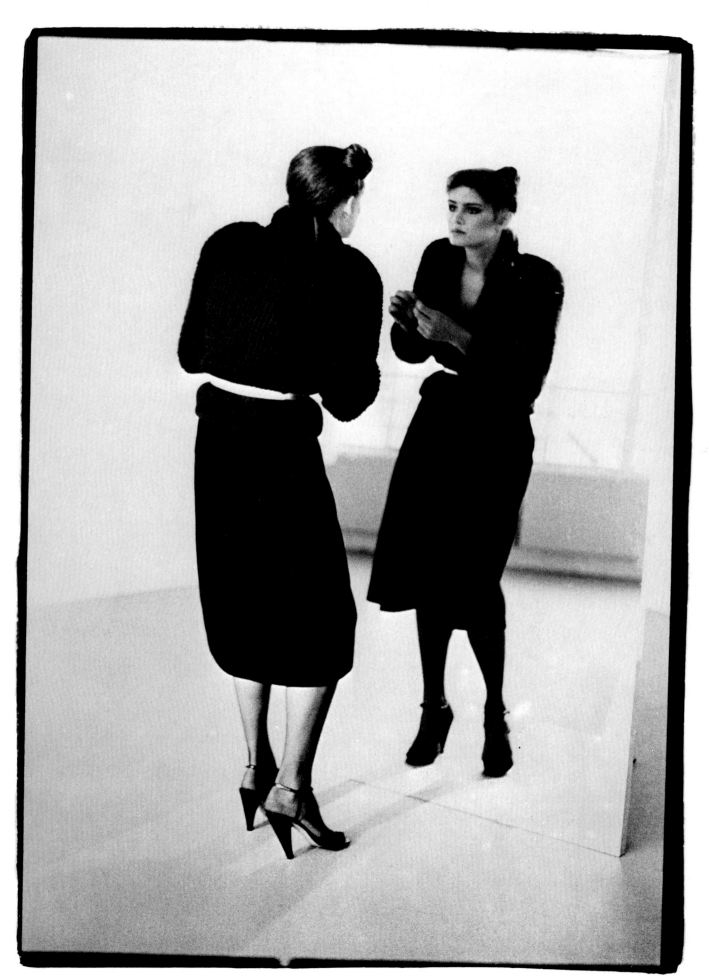

JULIE FOSTER IN THE MIRROR

POLLY MELLEN

ROSEANNE COMING ONTO THE SET

11.22.77-49

PETER KEATING

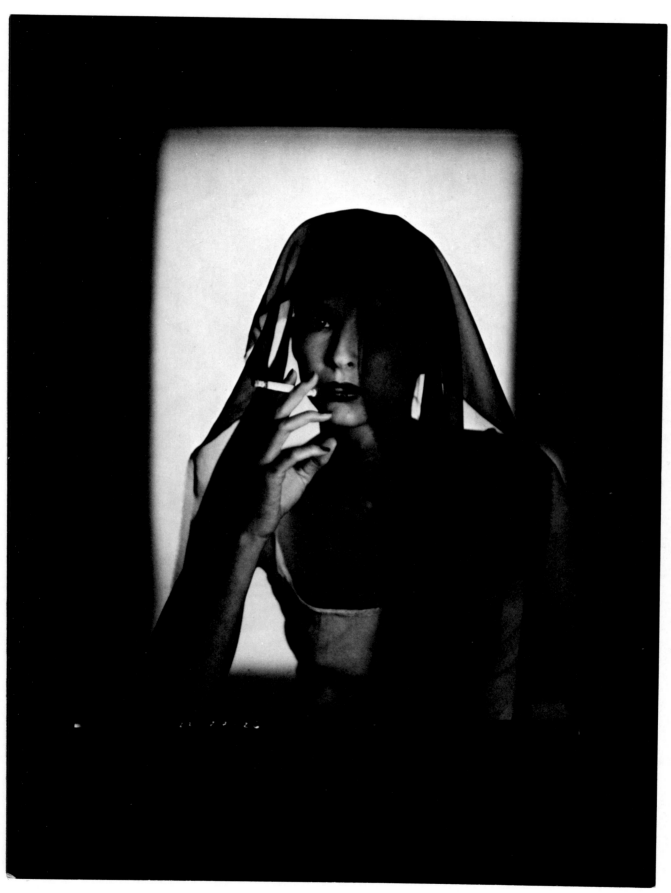

KAREN BJORNSEN

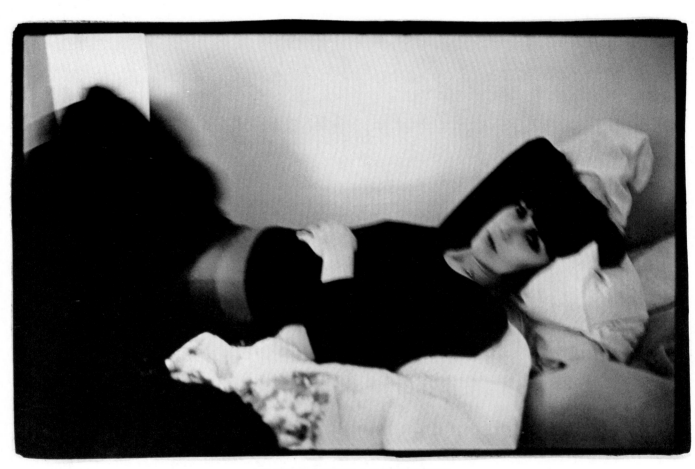

MAKEUP ARTIST SANDY LINTER

ISA LORENZO ON THE CHAIR

PRUDENCE ON THE BED

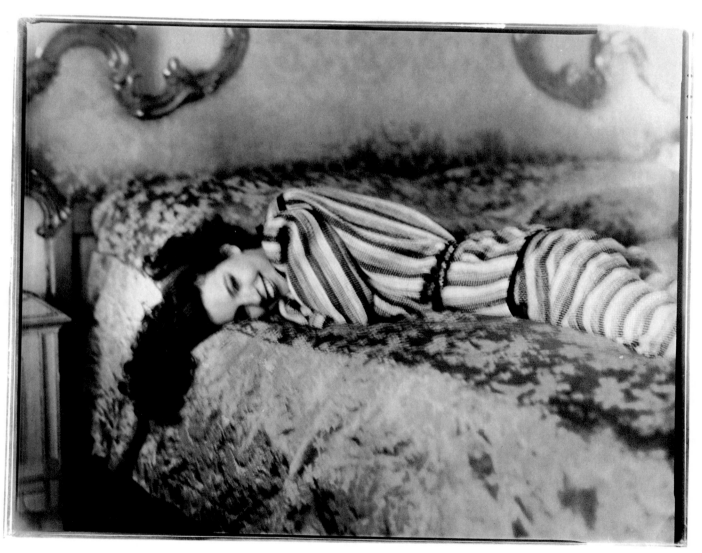

PRUDENCE ON THE BED

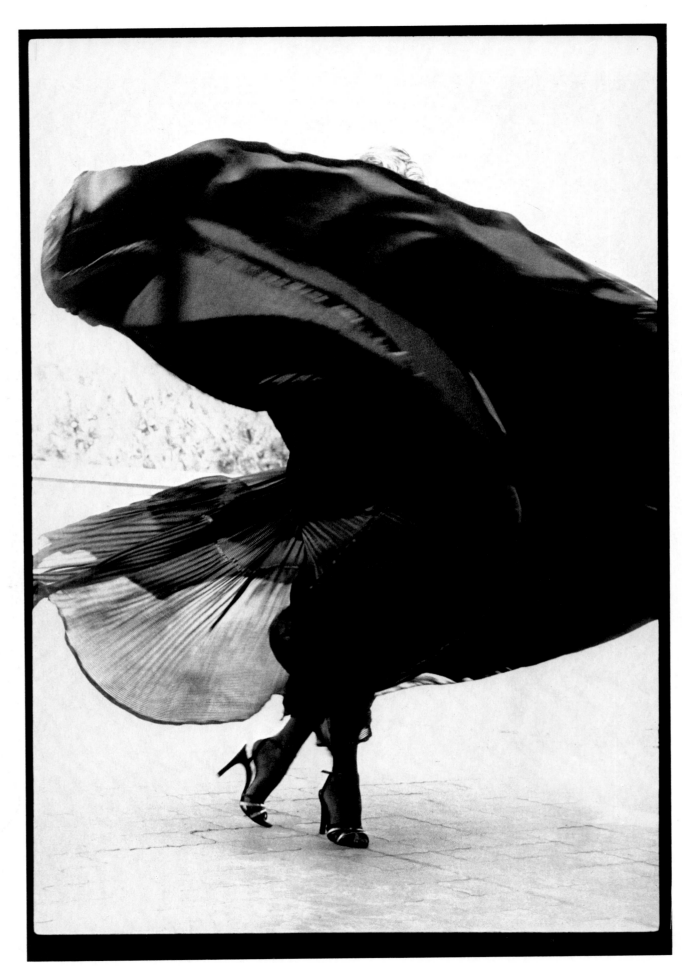

SHAUN CASEY DANCING

JULIE FOSTER AT THE PARIS COLLECTIONS

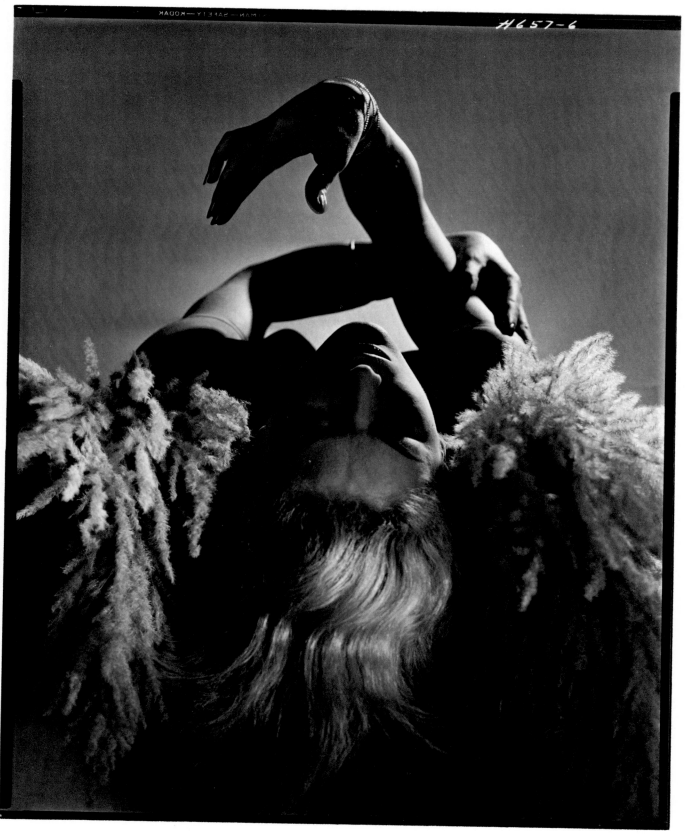

LISA

"The idea of fashion is change." HORST

When I was a boy, people from the early Bauhaus used to visit my family at our country house near Weimar, Germany. Through them I became interested in art and when I was 18, went to study architecture in Hamburg because Gropius was teaching there. After a year I wrote to Le Corbusier in Paris, asking if I could study with him. He wrote back to come any time. I went to work for him, but he was a difficult man and he had few jobs then. Le Corbusier was not very popular in France. He proposed to pull down the Marais, one of the oldest sections of Paris, and build workmen's flats there.

One day at a luncheon I met Dr. Agha, who was then the art director of FRENCH VOGUE. He asked me if I would like to photograph and I said, "I don't know anything about cameras or fashion." He said, "We'll let you have the studio twice a week and see how you make out." I went to this big VOGUE studio. There was an assistant, of course, and a model, all dressed up in black fox and a hat. I took a photograph and they published it.

That was in 1931. I didn't have a nickel and I didn't want to go back to Germany with Hitler gaining power. Fashion photography sounded promising, so I started to study. I went to the Louvre and looked at art books. I wasn't educated in art history. I knew as much as any school boy and that's it. But I began to learn from all the artists I met.

After two years, I photographed my first collection. In 1932, Mr. Nast of VOGUE brought me to New York. But before too long we had a row. Mr. Nast's knowledge of photography was incredible. One day, after he had gone through all my photographs, he said, "I suppose you think you're as good as Steichen." Steichen was his god, and there is no doubt Steichen was a great man. I said, "If I thought I couldn't become as good as Steichen I wouldn't have started." He threw me out. "That's the most conceited thing I've ever heard," he said. "You can leave when your contract is finished with us." I said, "I'm leaving tomorrow."

FRENCH VOGUE picked me up again. In 1935, AMERICAN VOGUE asked me to return to New York and I went back and forth two or three times a year to photograph the collections.

The whole point of photography at that time was to show the dress and make the woman look elegant. I was concerned with posing and lighting the model in attractive surroundings. For each collection, I designed three or four sets that my assistant and I built at night. I never knew exactly what dresses were coming out in the collection and I had to interpret each dress within a set. I might build one set inspired by the Italian Renaissance, another inspired by classical Greece. THE WOMAN BETWEEN TWO COLUMNS, from an early collection, was influenced by Steichen's photograph

of Isadora Duncan at the Parthenon.

In those days we had no hairdressers, makeup people or modeling agencies. Girls just turned up or somebody knew somebody. I have no idea what they were paid, but it was very little. The girl in this photograph became my favorite model. She used to deliver sweaters. I saw her waiting in the hall one day, and I said, "Oh boy." At first, Mr. Nast said she wouldn't be right, she wasn't elegant. She was a Russian girl and her nose was too short and thick. Later, he nearly wanted to marry her.

I often photograph close to the subject. When I shoot interiors, instead of showing everything, I show a part that makes the viewer feel he is living in the room. It's the same thing in fashion. I show the essential part of the dress. For example, I shot the photograph of the WHITE SLEEVE OF A DARK DRESS, because in 1936 a contrasting sleeve was something never done before. Once I had my set constructed and the lighting worked out, I had the model put on the dress and walk around to see how it moved.

Light creates mood. I used one overhead spot, plus fill, to give this photograph an art deco, "constructivist" feeling. At VOGUE, they always used to say, "Let's get the drama in there." With spotlights, I got a dramatic, stage lighting effect. My average number of spotlights on a setup is four, but there is no precise formula. I use barn doors on the spots to taper off the light or open it up, to bring out details of a dress. Flat light doesn't make a picture for me. I want to change appearances by emphasizing a shape of the body in profile, a texture, a detail in silhouette.

Living in the thirties, we were influenced by many people and events. Dali designed dresses for Schiaparelli. Picasso was a great friend of Chanel. Jean Cocteau did fashion drawings for HARPER'S BAZAAR. So did Christian Berard, a marvelous painter and set designer. Everybody worked together, talking fashion and art. Today, artists and fashion designers are worlds apart.

About three years ago, I returned to my lighting style of the thirties. FRENCH VOGUE asked me to do an assignment after I had stopped doing fashion for a while, and I thought, nobody's used spot lighting for years. I tried using the old lights in VOGUE's studio and the result was a success. I photographed exactly the way I used to, but in a more modern, looser way. Saint Laurent said, "Fantastic. This is it." Now everybody's copying that style. All the ads in FRENCH VOGUE are done with spotlights. Today you can't buy one in all of Paris.

When I started photographing it was easier to be successful. There was little competition. There was only Cecil Beaton and Hoyningen-Huene. Hoyningen-Huene was the best, without comparison. Occasionally, when he had assignments in Rome in

the early days, I travelled with him as his assistant. I posed for him when he needed a man to model.

In those days, fashion wasn't for elegant women only. It was a part of life. Women who didn't have much money had little sewing ladies around the corner who copied the designers. They were just as elegant as some of the rich women. It was Chanel who made it all simpler.

Chanel had taken the corset out of fashion, but, in 1939 Mainbocher reintroduced it. I had never photographed a corset before and it was a tricky thing to do. Again, the lighting in this photograph is more complex than it looks. It appears to be one light, but there was more to it, with fill and reflectors. I don't remember how it was done and I couldn't repeat it either. It was done not with thought, but with feeling. It was the last photograph I made in Paris before the war. I finished it at 4 o'clock in the morning, packed up, and got on the boat train at 7 o'clock that same morning. There is a moody sadness and eroticism to the picture. The war was starting and I was saying farewell. I took the last ship, the Normandie. Two days after it arrived in New York, it sank and the war broke out.

In the thirties, we shot only 8 x 10. We used a large format camera on wheels and 8 x 10 glass plates. When the war started there was a shortage of film, so we used 4 x 5. Then after the war I began to use a Rolleiflex, which I still use today, always with a normal lens. I'm not somebody who works only one way. Just last year I started using 35mm for the first time. I did the last Paris collection with a Nikon. At first I couldn't see through the viewfinder, but now I'm used to it. The Nikon is versatile and I like the light meter. I use it hand-held, or on a tripod.

THE NUDE is from the forties. I wanted to learn to draw and Bernard Lamotte, the painter, gave me lessons. This girl was one of his artists' models. She used to come to the dinner parties he gave at his roof apartment across from the Museum of Modern Art, in New York. Marlene Dietrich was there with Jean Gabin. All the people here from Europe would sit around playing records from Paris and crying like crazy. In the photograph, I wanted to make a classical angle with her face in silhouette.

In 1942, I went into the army for two years. I photographed generals and covers for YANK, the army magazine. When I got out, Mr. Liberman said, "You must come back." I said, "I don't know whether I can do it anymore." When I started again it was quite different. I shot advertising, cars, and fashion, but I got bored with it.

When Diana Vreeland started at VOGUE I sensed she wanted something different. I started to use strobe for the first time.

I didn't like them, because I couldn't see what I was doing.
I could get the correct exposure, but I couldn't control it. I was
used to working with tungsten spots and giving my attention to
how light would strike a certain detail on a dress.

Then Diana Vreeland asked me to photograph Madame
Jacques Balsan's house. I had never photographed a house before,
but she said, "You must do it. If it takes you three months, do it,
do it, it's very important." I went with a Rolleiflex and snapped
everything. I didn't care whether it was daylight or the right film.
I just went on. Apparently, it was sensational. I did something
different and it started a revolutionary way of doing interiors.

Sometimes a photographer must shock the reader, stimulate the
reader until she begins to like what she sees. Once I asked Diana
Vreeland, "What do you think the reader is going to say to that?"
She said, "The reader? We tell the reader what to think."

Today, it is unnecessary to explain a dress as a dress. I did a
fashion portrait of Picasso's daughter, Paloma, to show the strange
dress she wore to her wedding. I tried to interpret the mood of
the dress and get a feeling of Picasso in the photograph. The dress
doesn't show. It's just a part of the composition.

The PORTRAIT OF PALOMA was chosen by the editors of FRENCH
VOGUE. Another was chosen by AMERICAN VOGUE. I rarely edit
my own contact sheets. It's very difficult for me to choose the
best picture.

Getting a dramatic feeling in a photograph is not as difficult
today because professional models are sophisticated. Janice
Dickinson is better than any model I used in the 1930's. She feels
a dress by playing in it. In a most extraordinary way, she loosens it
up. She has a wonderful body and knows how to move.

Magazines pick the models, the makeup people and hairdressers
today. But I always tell the makeup people the girl must look
natural and not made up. The hair should look like the girl did it
herself. If the accent is on the hairdo, one forgets about the girl.
It's like being overdressed. Chanel used to say, "If a woman walks
into a room and people say, 'Oh, what a marvelous dress,' then
she is badly dressed. If they say, 'What a beautiful woman, then
she is well-dressed." The girl must look like a person. The dress
and makeup and hair are only to help.

Some editors are better than others. There are very few real art
directors. Art directing involves feeling the photographer out,
bouncing ideas around, reassuring and helping the photographer
work to full capacity. I like working on assignment with a good
art director. But there are editors who can destroy the shooting.
They haven't got a good eye, or they don't know what is going
to come out. When a shooting doesn't work, or people become

difficult, I can get furious. That helps sometimes. When you really get stuck, you just do what is necessary to complete the assignment, and go on.

The idea of fashion is change. Every year it's something different. Today, girls are photographed running in the streets. Munkacsi did it and many others. The trend has been a great success, but you can't repeat and repeat. The same is true for a magazine or a photographer.

Being stereotyped is a bore. It is difficult to overcome, but I like to change. If somebody would ask me today to do some naked women on the beach, I would love to do it. But nobody has asked me, because I'm known for my studio work. I can't say how I would do it. I wouldn't know until I started.

I'm 74 years old. In a long life like mine, you must do different things. That is one reason I quit doing fashion, then went back after years of photographing interiors. It is important to find new ways of looking at things.

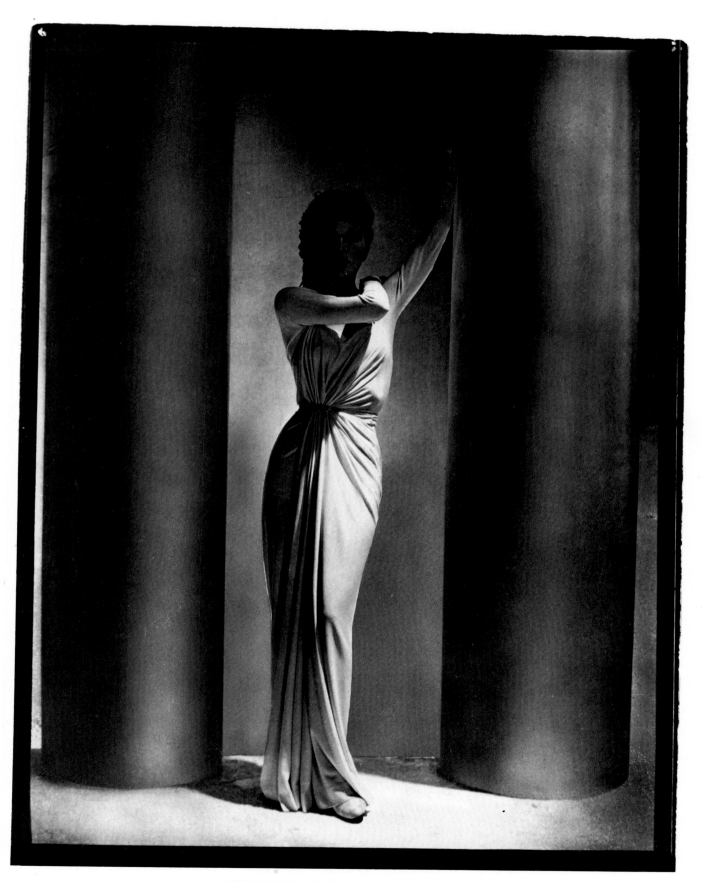

THE WOMAN BETWEEN TWO COLUMNS

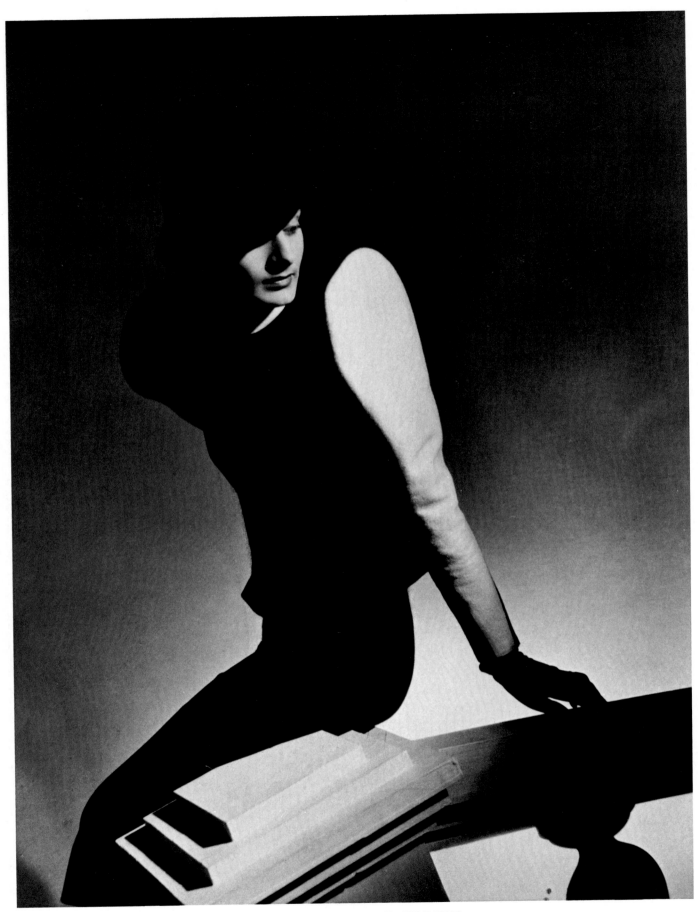

WHITE SLEEVE OF A DARK DRESS

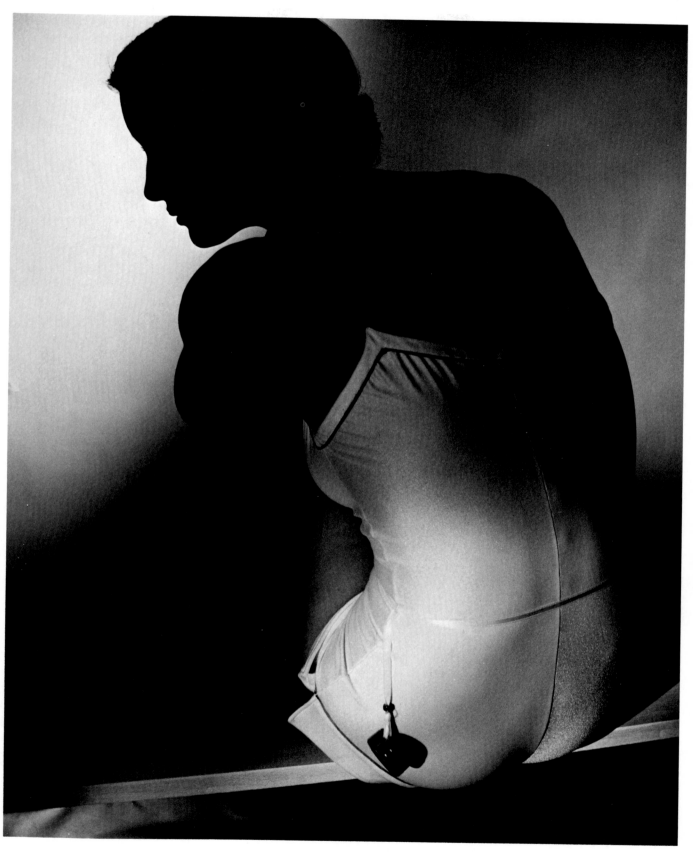

THE CORSET

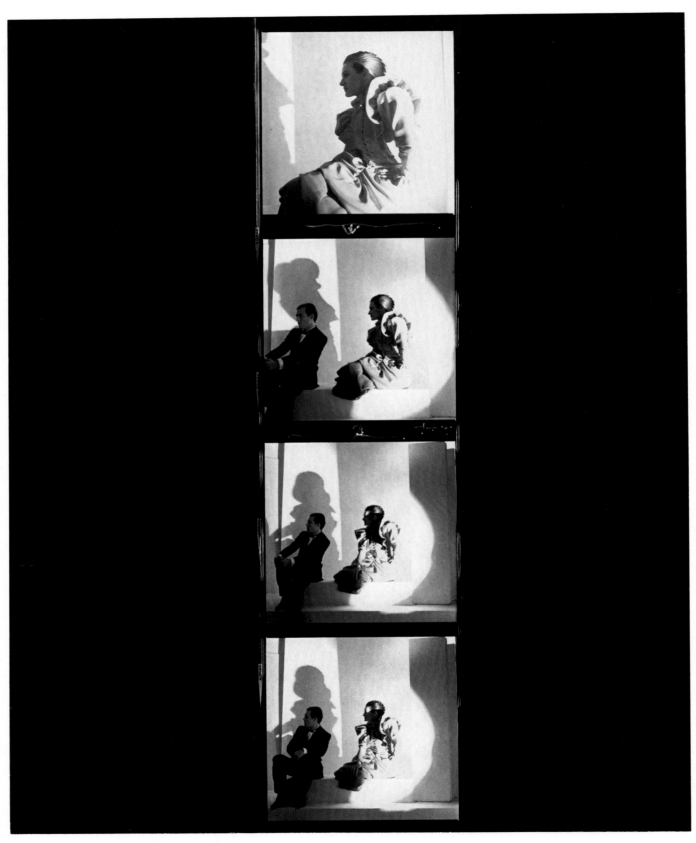

CONTACT SHEET FROM PORTRAIT OF PALOMA

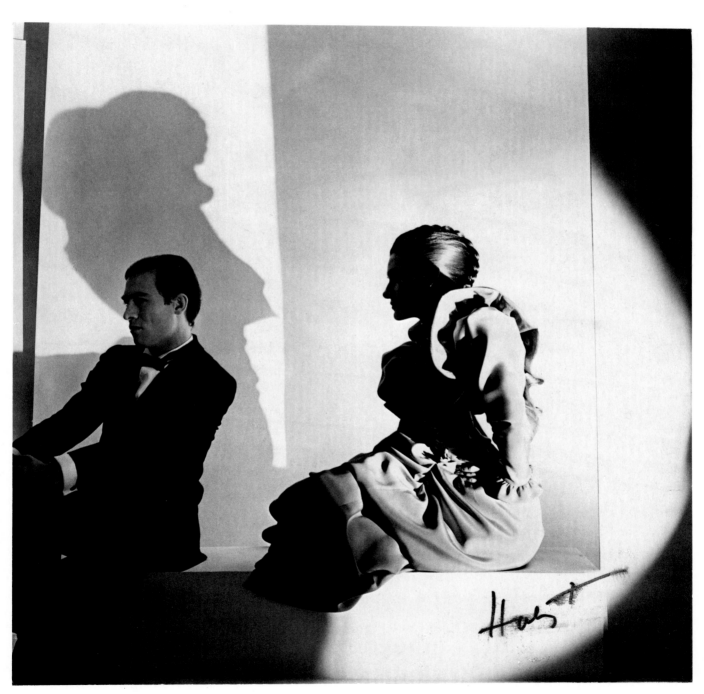

PORTRAIT OF PALOMA

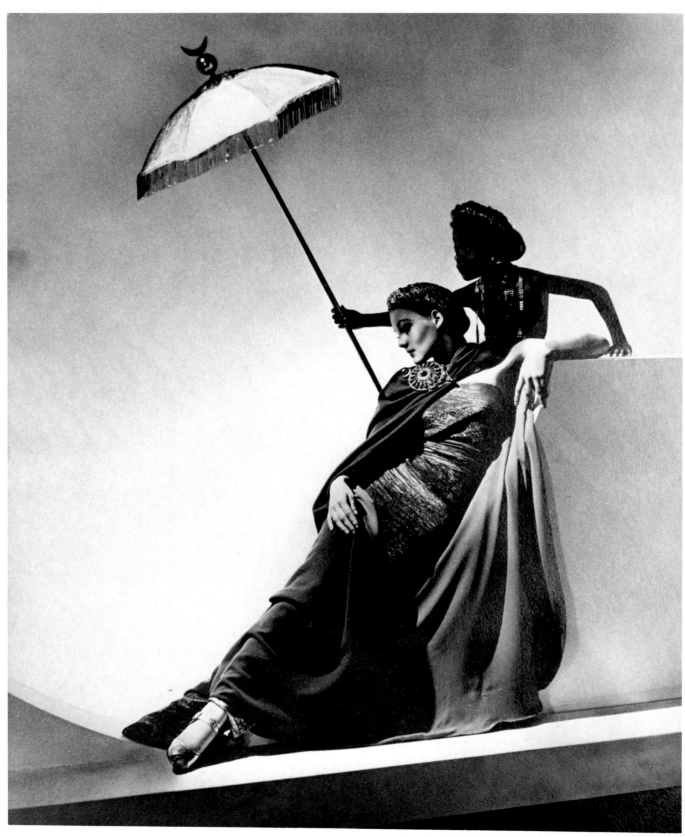

UNTITLED

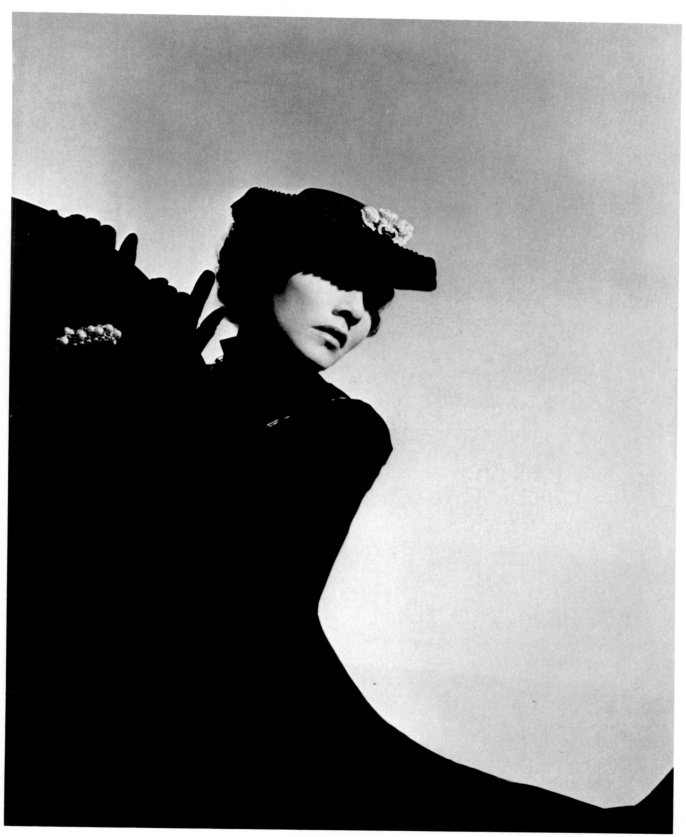

UNTITLED

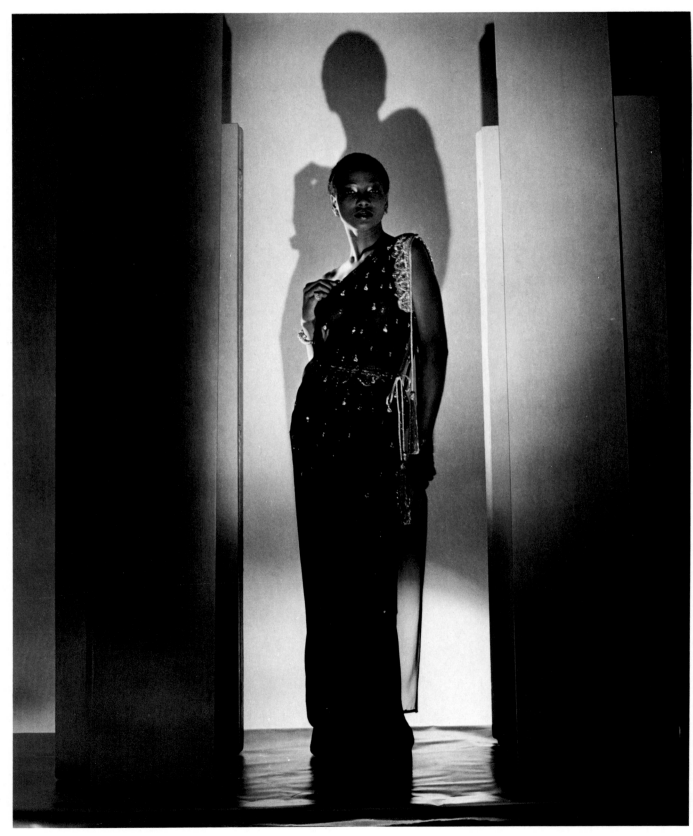

UNTITLED

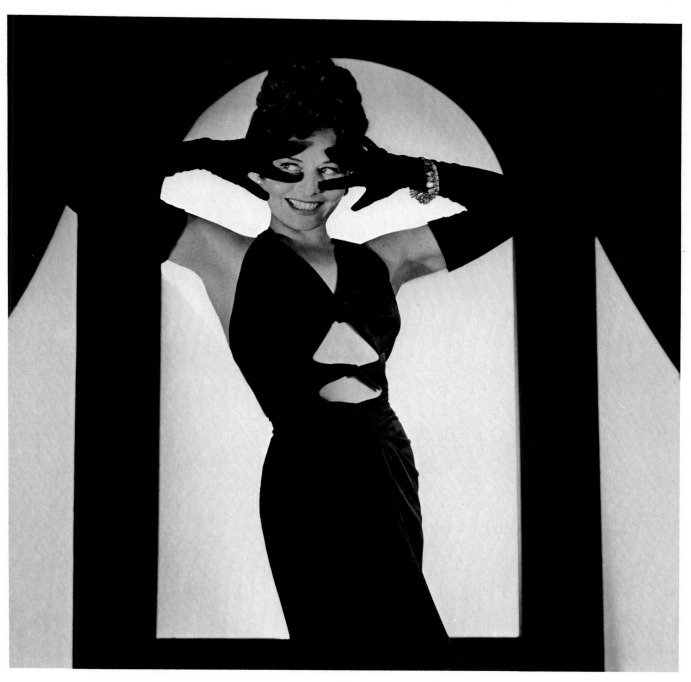

PAULETTE GODDARD

UNTITLED

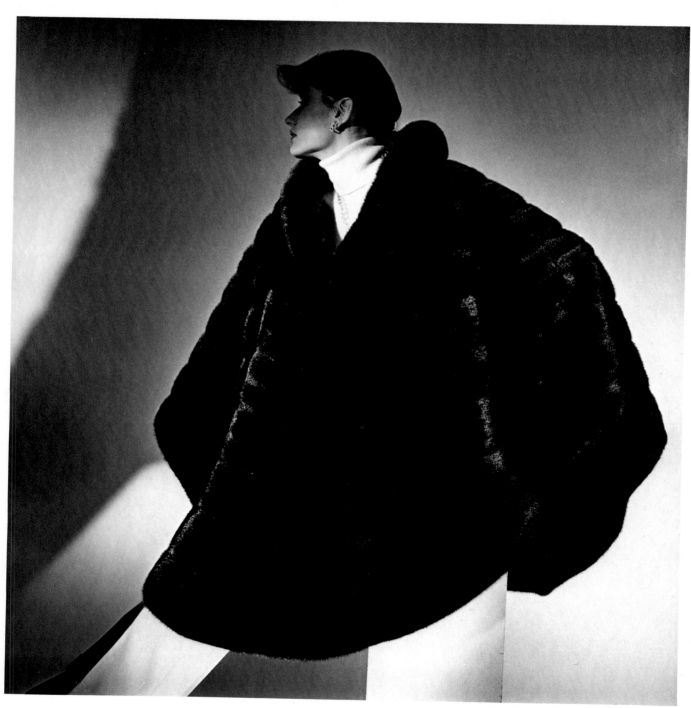

UNTITLED

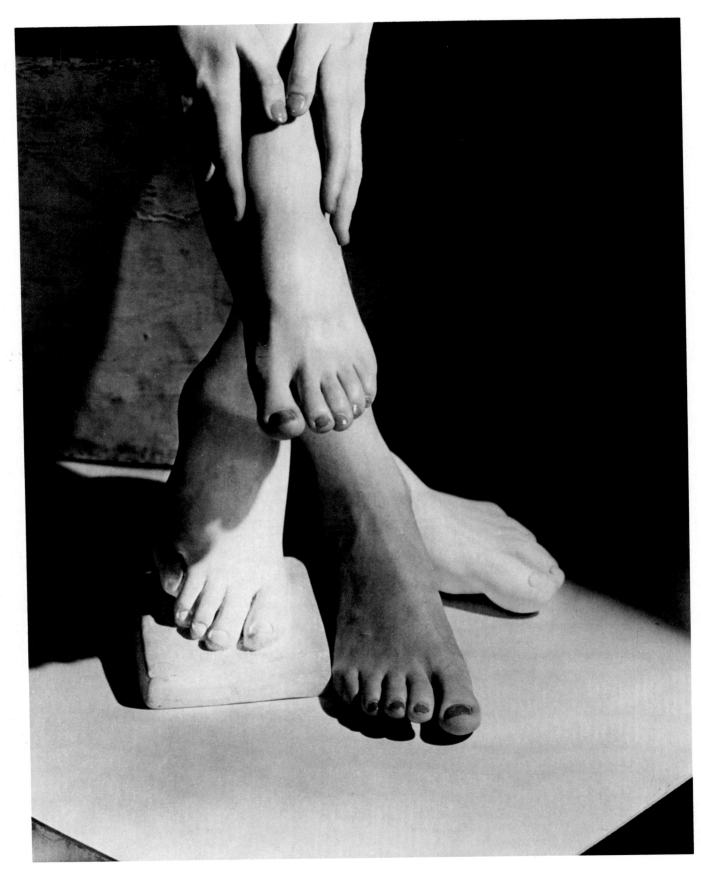

FEET

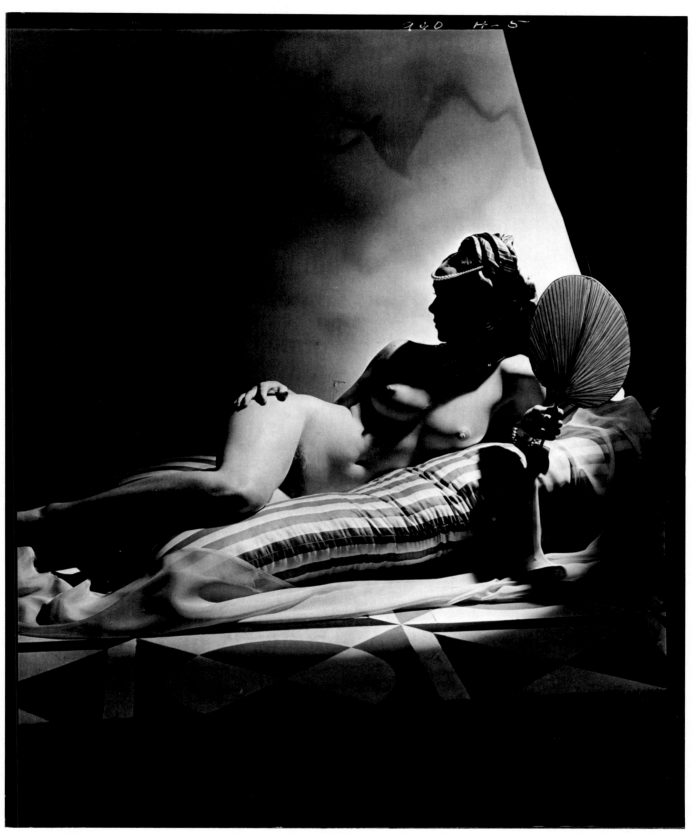

THE NUDE

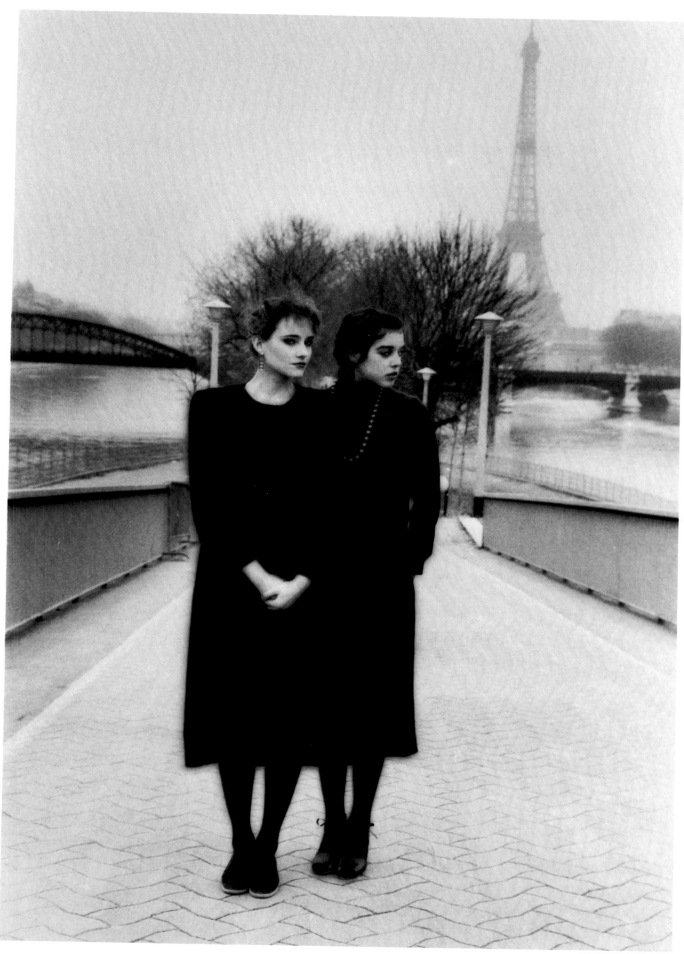

YVONNE AND NICOLE, PARIS, 1979

"Fashion photography is an extension of my work as an artist." ERICA LENNARD

What I find intriguing about doing fashion photographs is the idea that I am photographing a person, often a beautiful woman (even if the point now has become more and more reduced to the element of selling the clothes, perfume, etc.),and that I am still trying to make a photograph with the same aesthetic concerns that I bring to my own work.

The models I photograph are human beings with doubts about their beauty and who they are. In most fashion magazines, women look synthetic, unreal and unattainable. I try to work with girls who seem to have something beyond the perfect face and it is perhaps the rapport I have with them when I am shooting that helps to bring out that personal quality I look for. I am often very quiet, which surprises everyone since the classic idea of a shooting has always been loud music and lots of "Oh you look gorgeous, etc.," but I figure that they know they look good and I only try to direct their movements and make them relaxed enough to be natural. Still they sometimes ask "Do I look okay?" and that feeling of vulnerability is what I look for.

I like the hair and makeup to be as simple or unartificial as possible. There is always a team of people I feel best working with. I get ideas on how to pose models from looking at paintings, films and real life. It's difficult when you work with girls who have spent their time studying the pages of VOGUE to see how to stand. I often have to ask them not to hunch their shoulders over and not to put one hip out. Those kinds of movements have nothing to do with the way people really stand. I am constantly saying to the models, "Why don't you fold your hands in front of you, or keep your feet together." Sometimes during a shooting I may look around the room and notice the way one of the editors is sitting and that will give me an idea about how the model can be.

I consider my fashion photography an extension of my own work as an artist. I started five years ago to do fashion, and for five years before that, I'd been photographing women for myself. I made books and exhibitions (which I continue to do). The reason I wanted to do fashion was that with the particular vision of women I have I thought it would be interesting to reach an audience outside of the traditional photo world habitues.

A picture in the NEW YORK TIMES for Bloomingdale's or in MADEMOISELLE influences a different kind of woman, perhaps to re-think an attitude about themselves, feelings they can relate to instead of the frozen hard sex-symbols habitually seen.

When I was growing up in California, we never looked at fashion or thought about style in the traditional sense. Since then I have lived in Paris and New York where women are condi-

tioned to believe in the images presented to them in the magazines; fashion now is, of course, much more relaxed than it was in the fifties and sixties, and many magazines and designers I work with also agree with the idea of a more realistic and wearable, comfortable fashion and "look."

Everyone knows fashion is a business, but when I started, I was totally naive and romantic. I didn't really know anything about the procedure for getting jobs since I had never worked as an assistant. I used to go around to art directors with portraits of my friends. Even though I knew that these girls could be replaced by models, the magazines thought it would be great to give me a job if I could use my friends and were wary of having me do a real shooting. I had a hard time making a living in the beginning, as everyone does, I suppose, and for a while thought about being an assistant. But after seeing the first real fashion photographer who told me he preferred Japanese assistants because they worked the hardest and never complained, I decided I should just keep doing my own work.

About six months later, I went with my portfolio to ELLE Magazine. At the time, in 1975, it was one of the most innovative magazines in Europe. The art director, Peter Knapp said, "You shouldn't be an assistant. You already have a style. Don't put together a fashion portfolio. Just keep doing what you're doing, because it's strong and even if you're not going to work, you shouldn't compromise."

It took about a year until I got my first assignment at ELLE. One of the editors of ELLE had been to China; it was a very important experience for her. It's a country where everybody dresses more or less the same way, the hair and makeup are simple and essential. Yet all the women seem to be beautiful and happy. She wanted to convey that idea without using Chinese clothes—just comfortable Western clothes. Originally they wanted me to use my friends as models but it didn't work out, so they found a young girl who later became a very well-known model. I shot these photographs at Versailles behind the gardens.

It was February and the sky was dark with clouds. It had been raining and the sun came out for a few moments. I had them look into the sun because I liked direct sunlight in my photographs. Maybe the magic of photography for me is how light can, at moments, transform reality. I don't want to lose that magic and be in a studio and say, okay, all these photographs will be controlled with artificial lights. I'd rather make a document of what happens in a room or a landscape at a point when light is falling a certain way and a model moves into it, or away from it. Technically I'm sure it is possible to re-create the quality of natural

light but for me the element of mystery would be gone. I do all my pictures in available light. If it happens to be overcast, then I shoot in a soft, even light. If the sun happens to come out, then I shoot in contrasty sunlight. Late afternoon light is ideal. However, when I'm doing 8 photographs a day, it's impossible to wait until the end of the day to do everything.

I had wanted to photograph Dominique Sanda for a long time. In 1977, I was at the Cannes film festival on assignment for a magazine and she was there for her film "1900." She was extremely busy but through mutual friends she heard my photographs were good, so she agreed. I arrived at the hotel early so that I would have time to choose a location as I knew I would have very little time for the shooting. I walked around the lobby and decided to shoot on a stairway because the light was best for the kind of picture I wanted. When I went up to her room she said we could do it in the room, but I said I'd rather she came downstairs. She was wearing a dress designed for her by a friend in Paris, and the first thing she said to me when we got downstairs was, "You know, I'm really not photogenic."

I couldn't believe it. I had always thought how magnificent she was in films, and in person she had the same presence. I said that I was sure we could do a good photograph. She told me that when she's in front of a moving camera, it's completely different. She has her voice and her movement, and she can go through an action thinking about a part she's playing.

Throughout the whole session, she was insecure in front of the camera. At first she was standing and she seemed uncomfortable. She didn't know what to do with her hands. I had asked her to move into the area of the direct sunlight, then I asked her to sit down and lean against the bannister. Later, when I gave her the photograph, she asked me to come and photograph her again.

I was using my Leica and a 50mm lens. I always work in 35mm. I exposed for her face, and overexposed because I wanted it bleached out. I diffuse black and white prints in the enlarger, with a diffusion disc attached to the lens.

THE NUDE was the first job I did for ITALIAN VOGUE. The editor called me from Milan and asked for a beautiful nude. I chose the model and the hairdresser. We went to a friend's house and spent the afternoon doing the photograph. It was shot on a bed, with the afternoon light. The exposure was made for the highlights.

In many fashion photographs, you don't see the girl's face because she's looking away or the exposure is made for the dress. I burned in the sky and background, and dodged the face of THE GIRL ON THE PIER IN SANTA MARGARITA, ITALY. For this advertising shot, things were rather disorganized but that's normal in Italy.

The dress was too big and the shoes were a pair she just happened to bring along, but the photograph worked well in the end. It has a kind of timeless quality that I like very much to evoke.

I went to Italy to do some photographs for Luciano Soprani for ITALIAN VOGUE. We drove to a seaside resort, 3½ hours from Milano, in an uncomfortable van and when we arrived, there was a terrible storm. We'd called before we left and, maybe being Italians they said, "Oh, the weather's beautiful, come down, it's wonderful." It was obvious that there had been storms there for weeks because the entire beach was devastated. I wanted to photograph on a clean, white, sandy beach with the ocean behind, but there were piles of wood and junk all over the place.

Everybody was upset and the editor said, "Let's go back to Milano," but I don't like to give up. I've never reshot a job and I've never been rained out or unable to shoot because of weather. You would think somebody who uses available light would have problems, but even in London in the rainy season, I always managed to do my jobs. So I said, "Let's stay."

The sky was gray, the clouds were dark, it was cold, but I said, "Let's just drive along and try to find a place where we can shoot." I found these little beach houses, and then all of a sudden the sun broke through low, heavy clouds and it was an extraordinary moment. Everybody got dressed quickly and I shot the whole series in 45 minutes, the time the sun stayed out.

The last photograph was taken after the clouds came back. The light was low and it was freezing but I wanted to finish. I found a place that was sheltered behind the beach cabanas and my brave models went back there. The wind was blowing hard and it gave the photograph an animate quality—the hair and clothes and everything was moving. I told one girl to look away and the other one to put her head down.

I shot it with a Leica and a 50mm lens. The print is diffused. The client was enthusiastic about the photographs, perhaps because the photographs gave the clothes the kind of personality and atmosphere they needed.

I used to diffuse all my photographs, but unfortunately reproduction in magazines is very bad. When there are details on a black dress, they melt away because the ink isn't controlled in the printing. I like the blending effect but editors sometimes worry about seeing detail on clothes.

I used to develop all my film and print all my photographs myself. But now, when I shoot 50 rolls of film on a job and need to have the film the next day, I'm too exhausted to go into the darkroom all night. Actually, the labs know the way I want my negatives. I think the problem is more in the printing than devel-

oping the negative. Sometimes I end up making the prints to retain certain qualities in the sky and skin tones.

In Europe, magazines seem to give you complete freedom. They let you choose your models, locations, etc. The editor's job is essentially to choose the clothes, then to oversee the shooting and make sure the girl's clothes and hair will suit their audience.

In America, the editors are more concerned about maintaining a certain kind of look. Models are chosen from a small group of girls who are seen all the time in their magazines. Sometimes when I arrive for a job the editors and models are shocked. The fact that I'm a woman, look young and often work without an assistant and lots of equipment, doesn't inspire a tremendous amount of confidence.

For the last two years, I've been working with Perry Ellis, a New York designer whose clothes have an original and timeless quality. We seem to have a similar sensibility about beauty and how it feels to wear clothes. His clothes do inspire me and I re-interpret the moods that they seem to express. He knows very well what he wants but he always gives me complete freedom when I do his ads. Perry gives me the clothes and sketches of the way the outfits are put together and says, "Come back with a beautiful photograph." The kind of natural quality in the light and attitude of the girl in my pictures seems to be an ideal marriage with his designs. They are the kind of clothes I like to wear.

The photograph from his collection of 1979 has a Wuthering Heights kind of feeling for me. But when I went to do the shooting I did not have a specific image in mind. I knew that I wanted to shoot it in a forest or a garden so I went to Fort Tryon Park, being in New York at the time. It was one of the first warm days of spring and I went with Audrey Matson, a model I work with often. We chose this one because of the feeling of movement, going forward and looking back which seemed to reflect the idea of the collection.

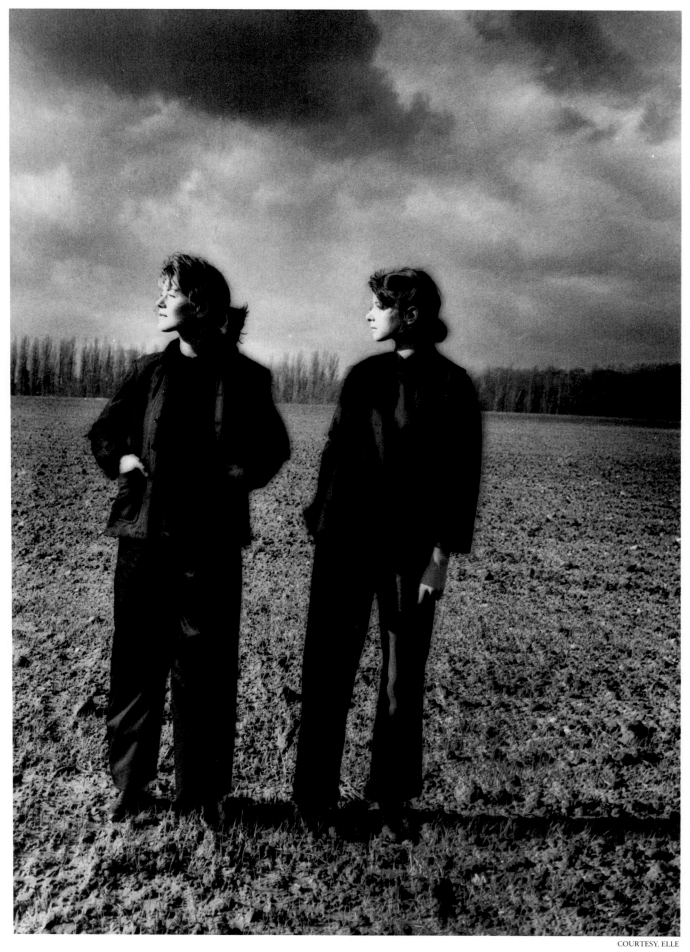

LES CHINOISES, FRANCE, 1977

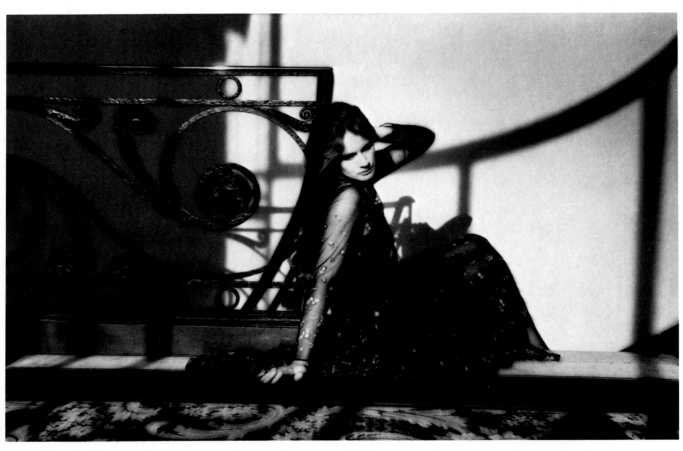

DOMINIQUE SANDA, CANNES, 1978

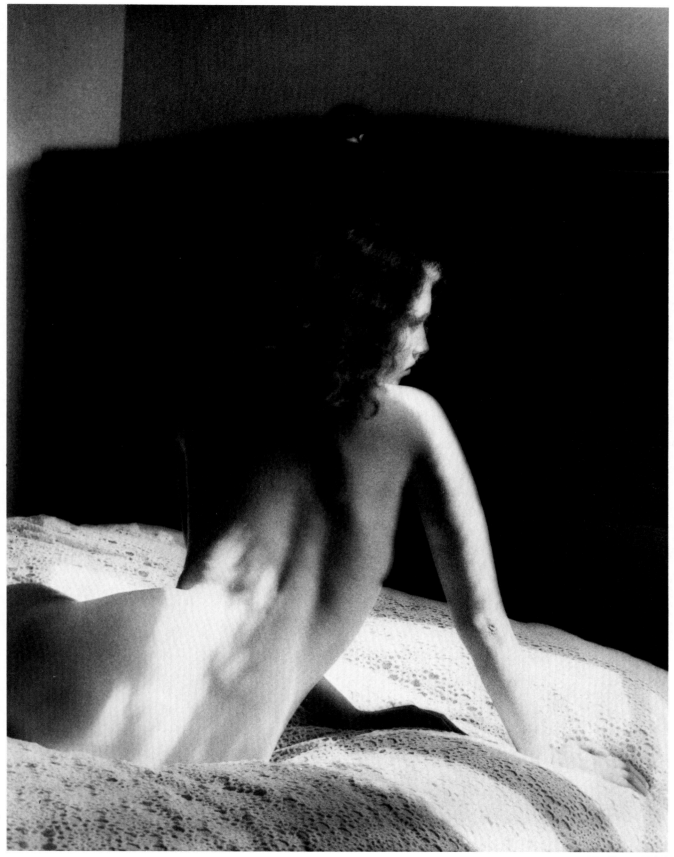

NUDE, 1978

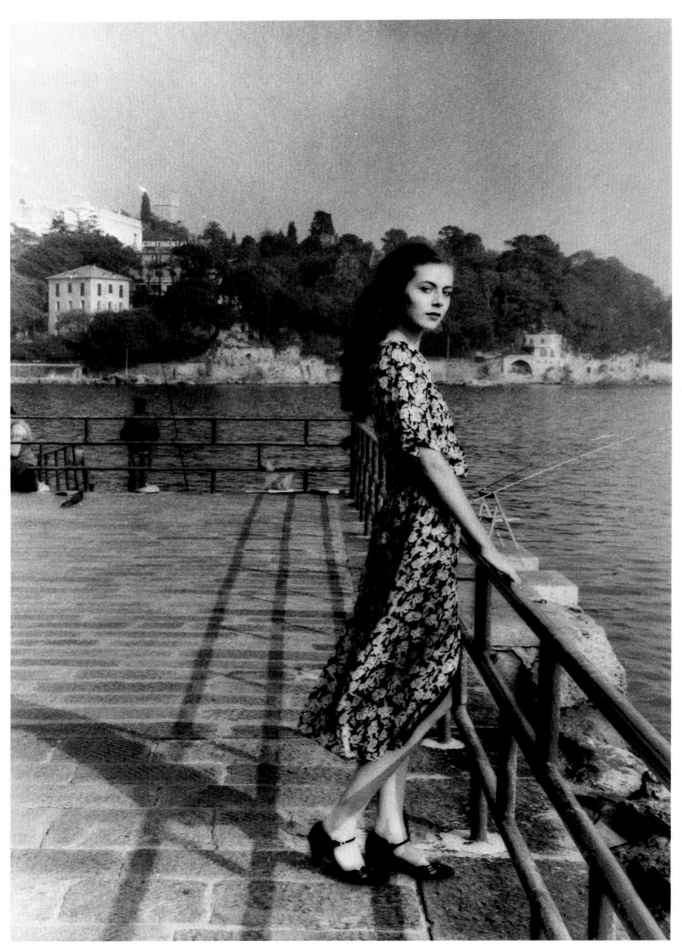

THE GIRL ON THE PIER, SANTA MARGARITA, ITALY, 1979

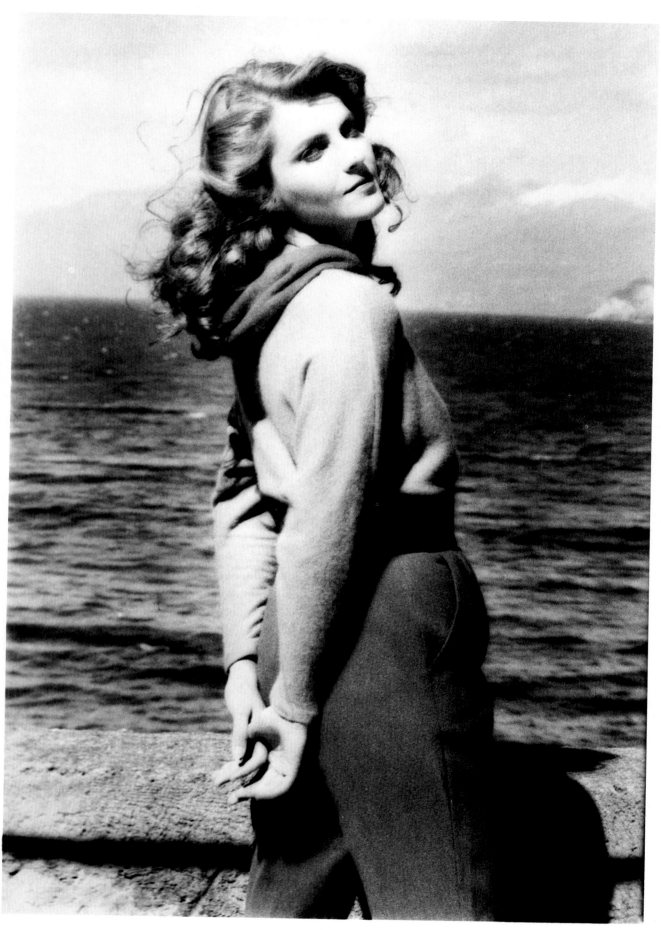

MELODIE, ITALY, 1980

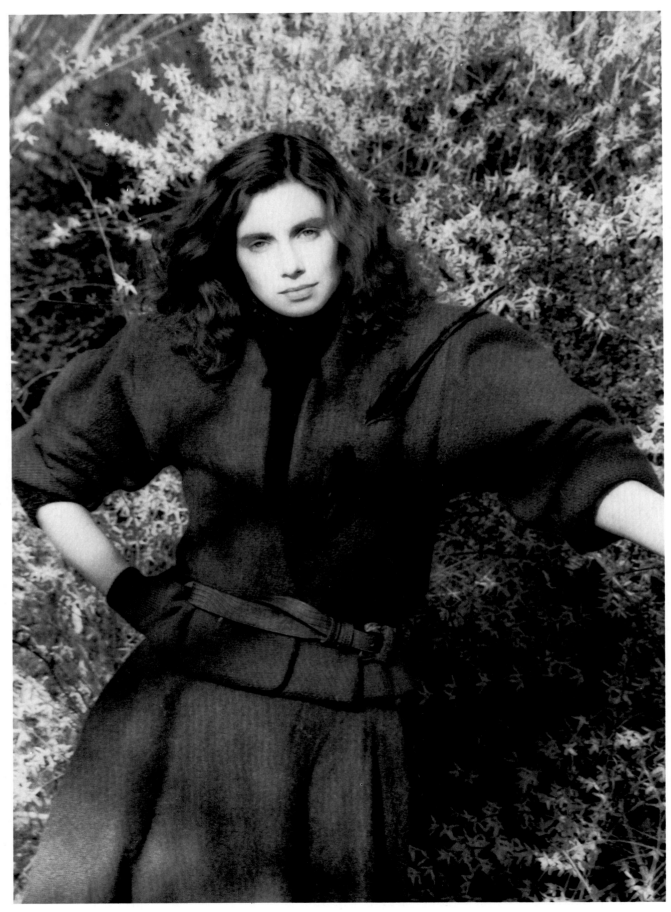

AUDREY MATSON, FOR PERRY ELLIS, 1979

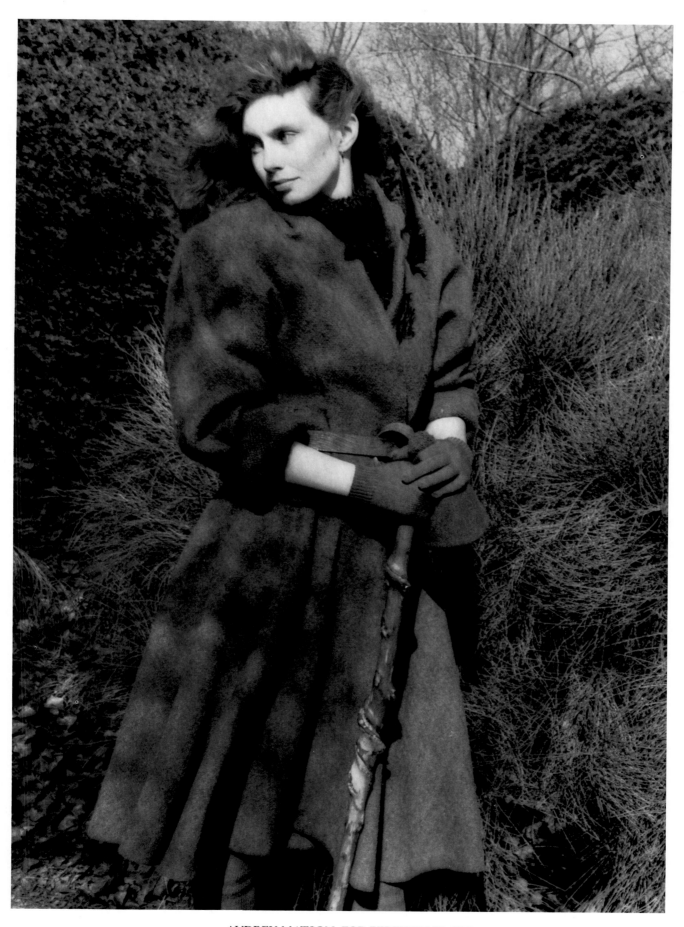

AUDREY MATSON, FOR PERRY ELLIS, 1979

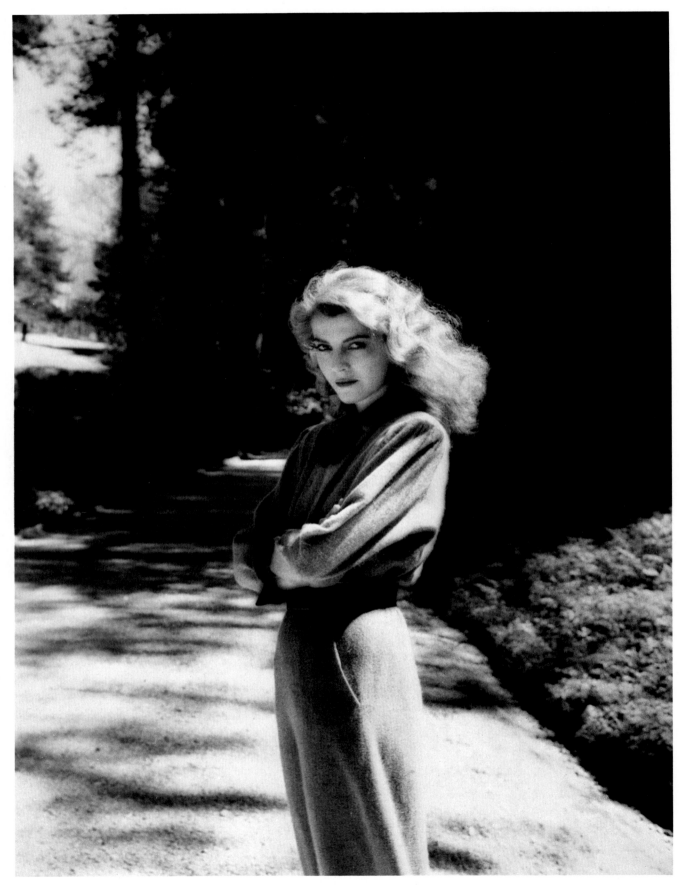

UNTITLED

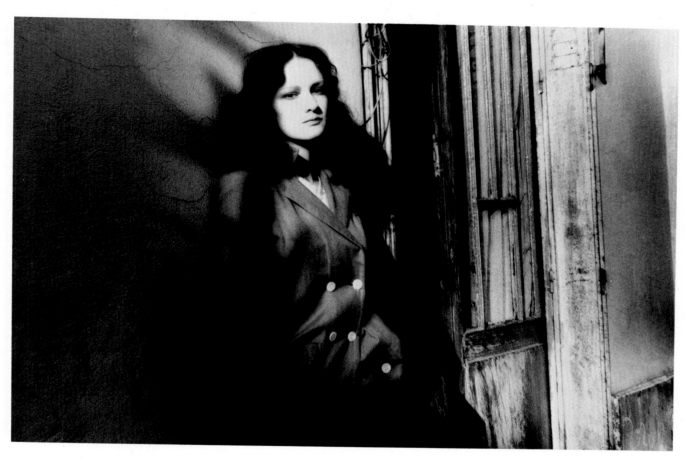

UNTITLED

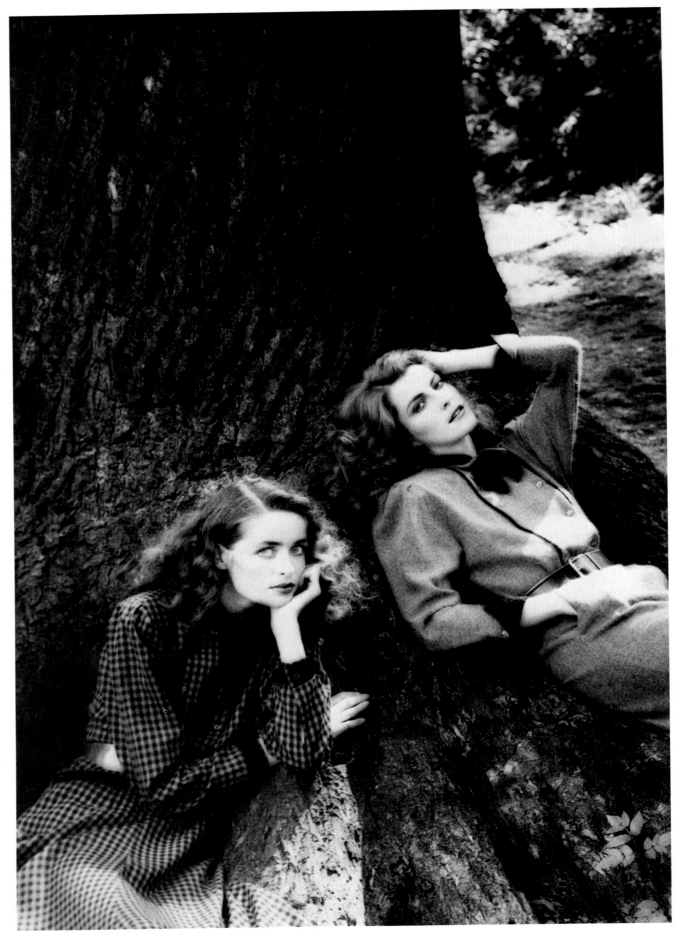

UNTITLED

UNTITLED

UNTITLED

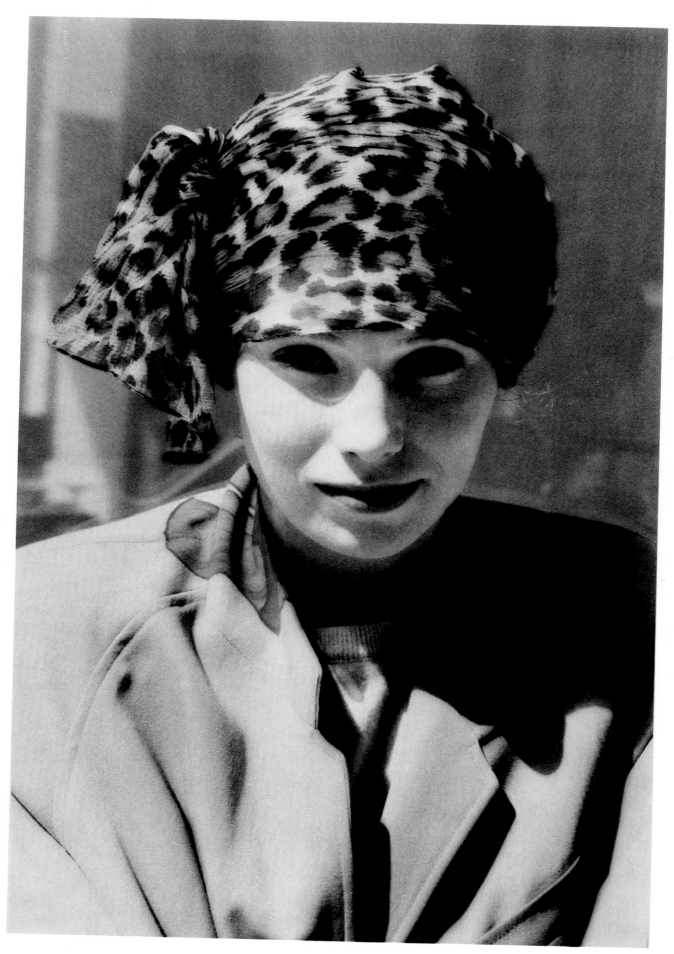

AUDREY, DEAUVILLE, 1980

"I'm attracted to a feeling of mystery, to something unspoken." JIMMY MOORE

When I was 12 years old, a friend bought me a Kodak Bantam 828 camera for Christmas and taught me how to develop and print. I had very little patience as a kid and was constantly criticized for pulling my prints from the developer. When I was 19, the same friend suggested that I take a class with Alexy Brodovitch. I took his advice and it was a very important step in my life. Classes were held at Steve Calhoun's studio on East 55th Street. It was my first exposure to a professional studio and photographers which was all very exciting.

Brodavitch always stressed finding out who you are, being an individual and never imitating what's been done before. He didn't care about print quality or that an idea was unfinished. People could bring in stats, as long as they showed an awareness and development in a direction that was their own. He said that first you must know yourself and have a point of view, and the technique will follow. Towards the end of the session, Richard Avedon gave a lecture and I met his assistant, Hiro. Avedon invited me to the studio and, one month later, offered me a job. I worked as his assistant just short of a year. Because it was my first job, I didn't completely understand all that I was exposed to at Avedon's studio. But my impressions stayed with me and started to mean something as the years went by.

After that, I worked as a freelance assistant for the still life photographers, Lester Bookbinder and Rouben Samberg. After each job Lester would sit down with me and answer any technical questions I had. When Rouben was shooting color, he would have me run a test on every filter possible. If we had a free day, he'd have me print a negative on grades zero to five paper to get the best print. It was an invaluable education and, after two years with them, I went into business as a still life photographer.

Still life is a discipline through which one can develop a personal point of view because everything in the picture is a conscious decision labored over. For three or four years, I worked on all the still life accounts and was quite successful but, after a while, the control drove me crazy. One evening I went to dinner and came back to the studio to work. When I saw everything exactly as I had left it, down to the frost on the Coca Cola glasses, I felt like time had stopped. That I needed a change became apparent. I threw everything out, cleaned my studio and fell into a depression for about a week. Then I decided to make a picture without depending on elaborate props. I set up three cardboards, put some unraveled thread in the corner and started shooting. Not until I went into the darkroom, did an ABSTRACT NUDE appear to be the result. I decided to be a fashion photographer and began to test. While making the transition, I continued to do

limited still life.

Marvin Israel gave me my first break. A few days after he saw my still life portfolio, I received a call from him with a fashion assignment. It was a half page photograph for the front of the magazine. My first full page assignment was a beauty shot for a story on foot health. I was called to the magazine for a meeting, and was ushered into a room with five or six editors. They discussed the assignment among themselves and then asked me what I wanted to do. I had no idea. Off the top of my head I said, "A foot on a rock." They liked the idea, so I was committed to it. The sensation of standing barefoot on cold stone probably was part of what I wanted to convey.

Grain is the character and substance of a film. If it is there, I want to see it, especially in the areas around a figure. The grain in the photograph of the SHOES AND LEGS, shot against seamless paper, gives a feeling of place by suggesting the figure is enveloped in air filled with particles of dust. This was shot in 1965, also on Royal-X Pan developed in DK-50.

The COLLAGE OF THE EYES was influenced by the "Art of Assemblage" show at the Museum of Modern Art. The energy in the work was tremendous—totally free, illogical and inspired. Cutting and sticking a push pin into the photograph destroyed all the serious and familiar attitudes I had about taking pictures. Actually, it's difficult to be objective about this, or anything I've done in the past, because I remember the time and events that went into it. This a 35mm copy of the original, made with a Nikon and Tri-X. I bracketed and used the best negative.

The series of SHOES WITH STRING started from a shape I'd seen in a corner of a Picasso painting. I hammered a nail into the wall and tied a string to it. In a way, it was totally ridiculous but seemed to work. It's difficult to explain why I did it. What intersted me more were the acts of cutting, nailing and painting, of having the photograph take form.

This photograph was part of a six page assignment for HARPER'S BAZAAR. Very often the limitations imposed by an assignment gave me the incentive to push beyond it. The more limited and confined I was, the more motivated I felt. I probably would have found it more difficult had I been given more freedom. I decided on a 4 x 5 format, and developed it in DK-50. The larger the format of the negative, the closer I want it to the final contrast and density of the print. Negatives in 35mm and 2¼ formats should be slightly flatter than the print that I want.

The photograph of the FOUNDATION GARMENT was shot in 1966 for LOOK MAGAZINE. They ran a less abstract version that showed more of the girl, but I prefer this one. The lighting is

strobe, which I often use for it's dependability and consistency. The quality of strobe rarely changes. I think of it as light shot from a gun, traveling along a straight line, then falling off. Sometimes I like to work in the falloff area. In lighting a background, I aim the lights past the subject to keep it separate. I often use gobos to block the light in certain areas.

Exposures with strobe are determined with a Minolta flash meter. Whatever the reading is, I follow it to the quarter of a stop. If it is $f/16\frac{1}{2}$ with a $\frac{1}{4}$ stop filter compensation, I knock it down to $f/16\frac{1}{4}$. That way, if there are fluctuations, I know where to make adjustments. I almost never bracket my exposures. I've never trusted a Polaroid to test my exposure because the film is subject to temperature changes, and the ASA can very from batch to batch. I use Polaroids for positioning and lighting ratios.

The juxtaposition of the TWO SHOES suggested itself. I came to the shooting with my mind totally empty, the girl put the shoes on, and we went on set. I thought that in order to relate to the viewer, the shoes should relate to each other. I used two slightly different shoes on feet of two models to break the logic of one model in a pair of shoes.

The photograph of the WRISTWATCH came about after studying it on the model and trying many different positions. Finally, I found one that reminded me of Big Ben. Shooting up at it changed the scale.

Photographing the Paris collections was an exciting experience. In 1966, I covered them for HARPER'S BAZAAR and it was fun, but I don't think I could do it again. It was too hectic. I had three assistants, five models, an art director, editors, and messengers with me for 10 days. I went to the fashion shows to see the clothes, came back to the hotel to sleep, went back to the studio, and when the clothes arrived, shot them and waited for the next ones. I asked Alexandre the hairdresser for something unusual for one photograph and he came up with a BEAUTIFUL SCULPTURED BRAID. I placed the model's face in shadow to accentuate the hair lit with strobes through a large Rollux screen.

We brought all the chemistry for processing on the plane to Paris. But we ran into problems because the water in Paris seemed to be different, and a normal developing time of six minutes was reduced to about three minutes. A deep tank was used because it's easier to control the temperature of a larger body of liquid. We even insulated it in a water bath. The situation made me nervous because the shorter the developing time, the greater the possibility of errors. But it all worked out in the end.

When I shoot an ad, the art director will often ask me to move back or move in on a certain part of the subject, to leave room at

the top or bottom. If the camera position is changed, the lighting setup must also be changed, so, as a matter of convenience, I use a zoom lens to accomodate different framings. For years, I stayed away from zoom lenses for still photographs because, theoretically, there was always one point that was softer. If you happen to focus at that point, you're in trouble. I used zoom cine lenses because you move through the soft point and it is not that noticable. And now I use a Nikon 43 to 86mm zoom as well. I find that it's as sharp as any of my other lenses.

The fashion photograph of the GIRL IN BLACK was shot in a driveway in Southampton, Long Island. I used a long lens to keep the house in the background soft so it would look like a distant castle. I used to use wide angle lenses, but I rarely use them now. Most of the time I used them as wide field lenses.

When I make a print to be reproduced in a magazine, I want to know the characteristics of the paper and ink and the method of printing. Most American magazines are printed on a high speed web press, which seems to affect the light tones more than the dark ones. By the time a half-tone screen is laid over the print, the contrast is knocked down, so I build it up in the print to compensate. It's always advisable to know where and how your photographs are going to appear.

What I look for in a model is difficult to describe. I think it's important for her to be intelligent, sensitive, sensual and mysterious. I'm attracted to a feeling of mystery, to something unspoken. It inspires me to want to make contact and discover the mystery.

In 1967, I started studying Tai Chi Chuan, and realized that somehow, unconsciously, I had been using some of its principles in posing models. The Tai Chi forms of centering and movement have made me more aware of body positions. Sometimes, I practice Tai Chi before I photograph to empty my mind and get rid of tensions that block my energy. It might sound esoteric, but the principles are the same ones used in sports, the arts, and just about everything else. I made my first unconscious photographs by accident, but, through methods such as Tai Chi, I learned how to cultivate the process, to be less subject to external influences.

I suppose there are universal shapes and ways of composing, but they cannot be forced. They have a way of happening as part of the intuitive process. When a photograph screams and jumps off a page bigger than life, it repels you just as some people do. When a photograph gives the impression of open space and quiet receptivity, it draws the eye in closer to see it. I prefer people who make eye contact, who attract by receiving and photographs that have a similar presence.

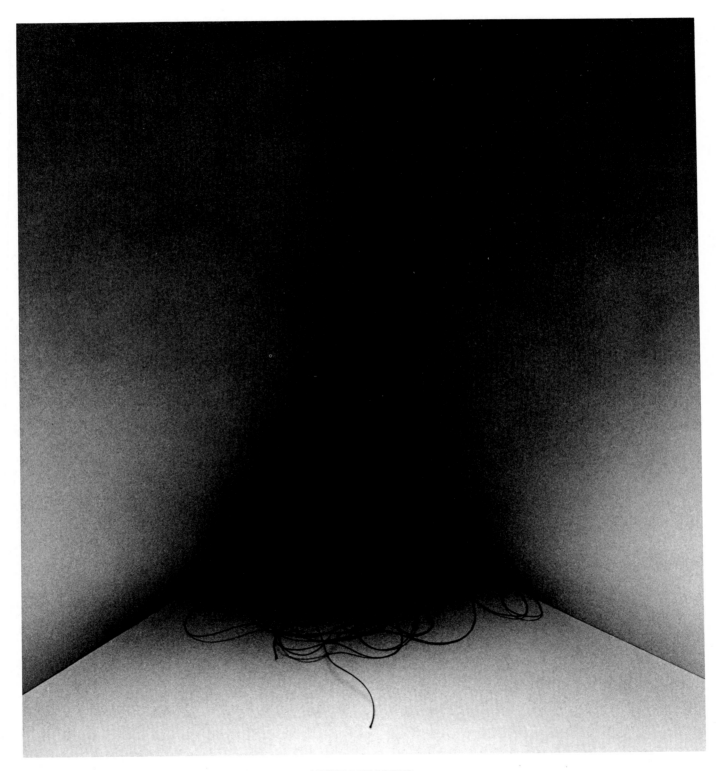

ABSTRACT NUDE

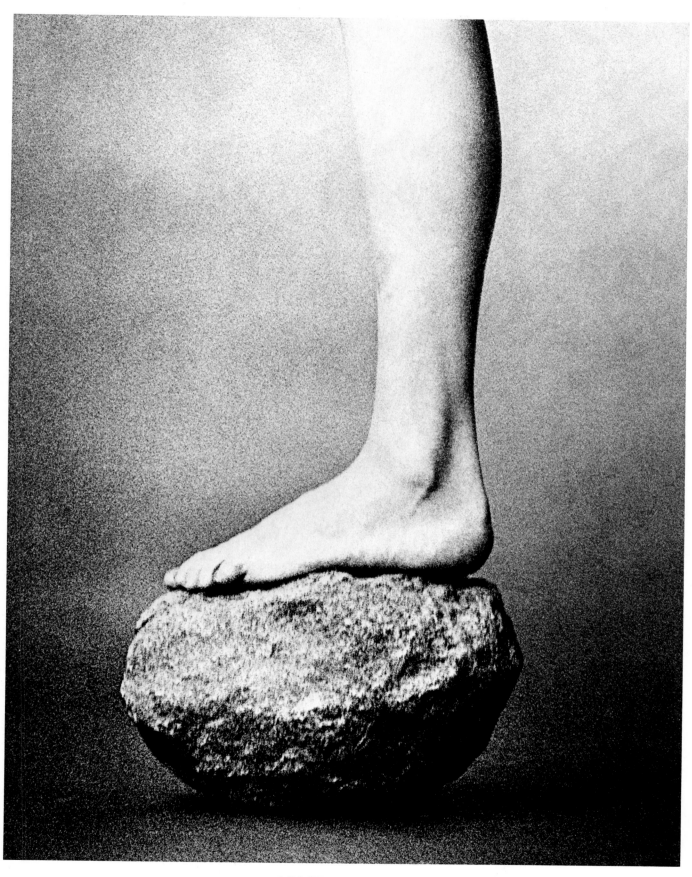

A FOOT ON A ROCK

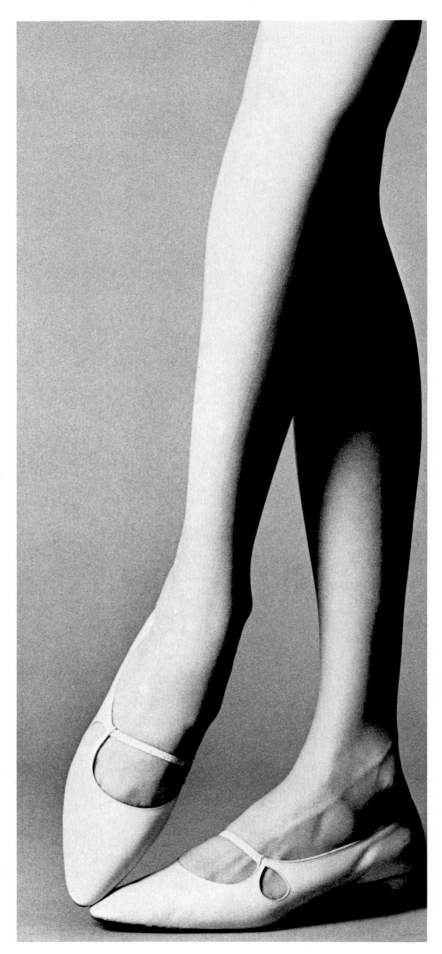

SHOES AND LEGS

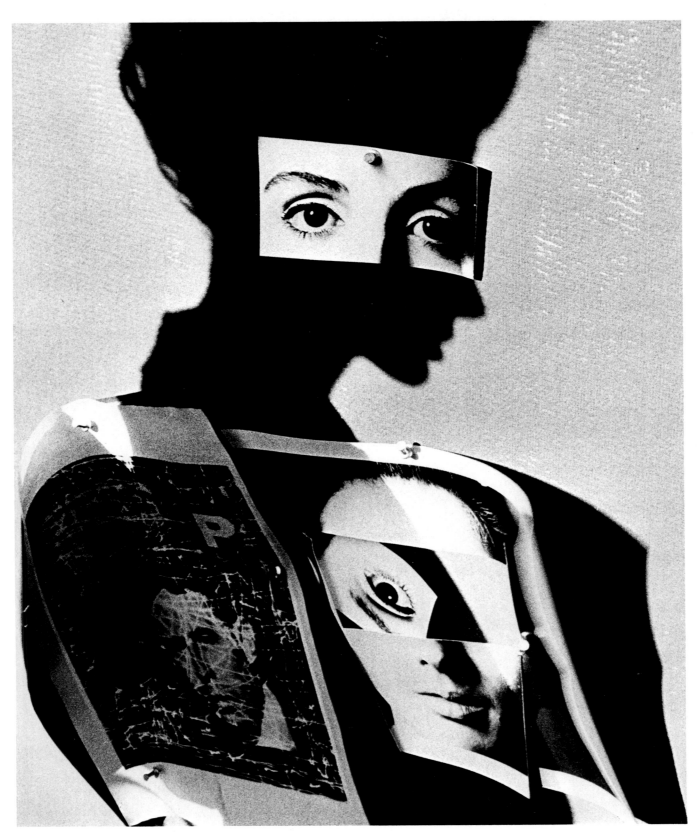

COLLAGE OF THE EYES

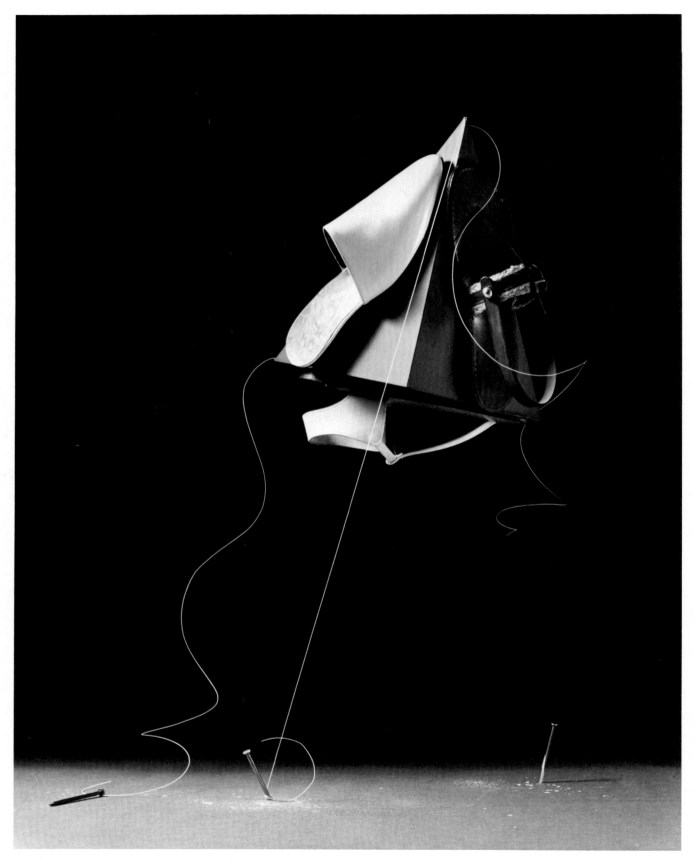

SHOES WITH STRING

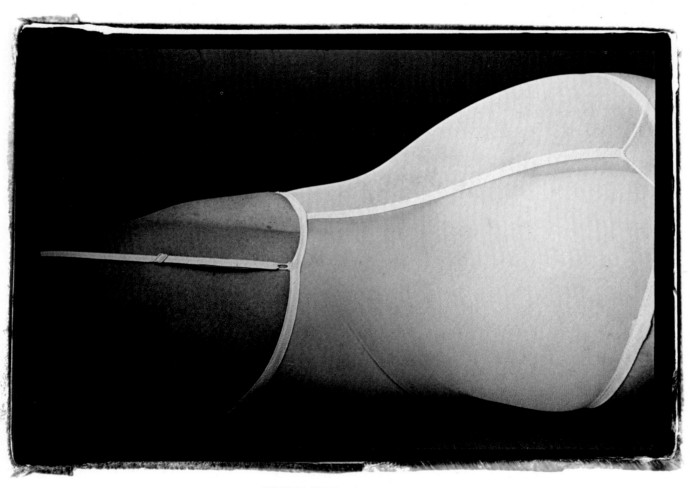

FOUNDATION GARMENT

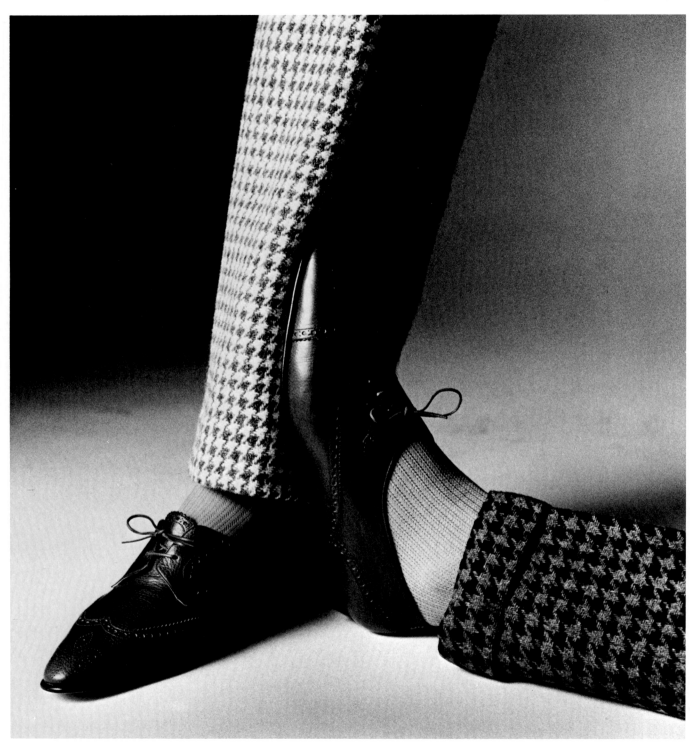

TWO SHOES

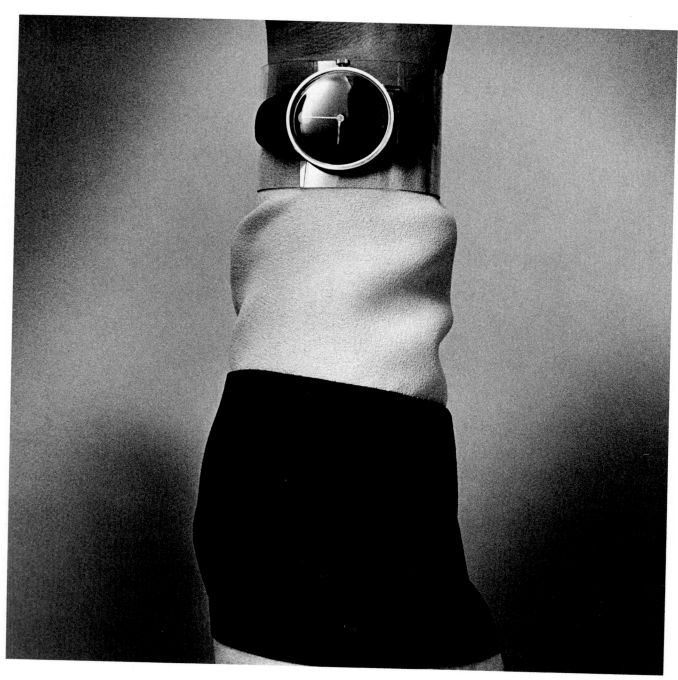

WRISTWATCH

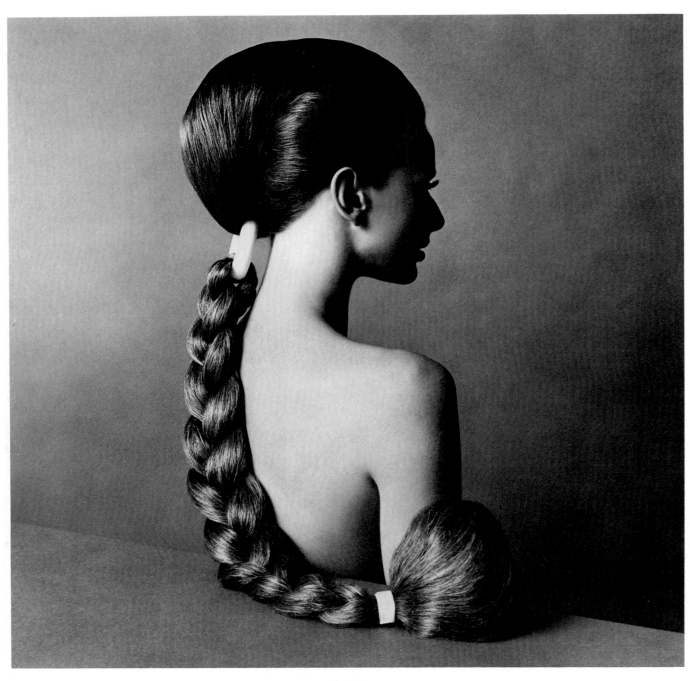

BEAUTIFUL SCULPTURED BRAID

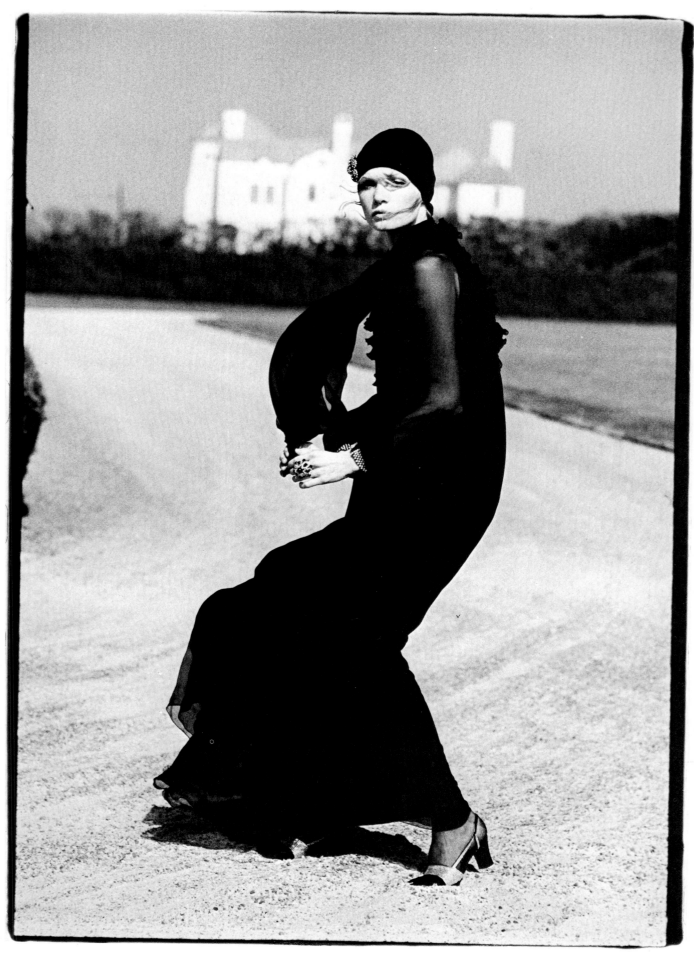

GIRL IN BLACK

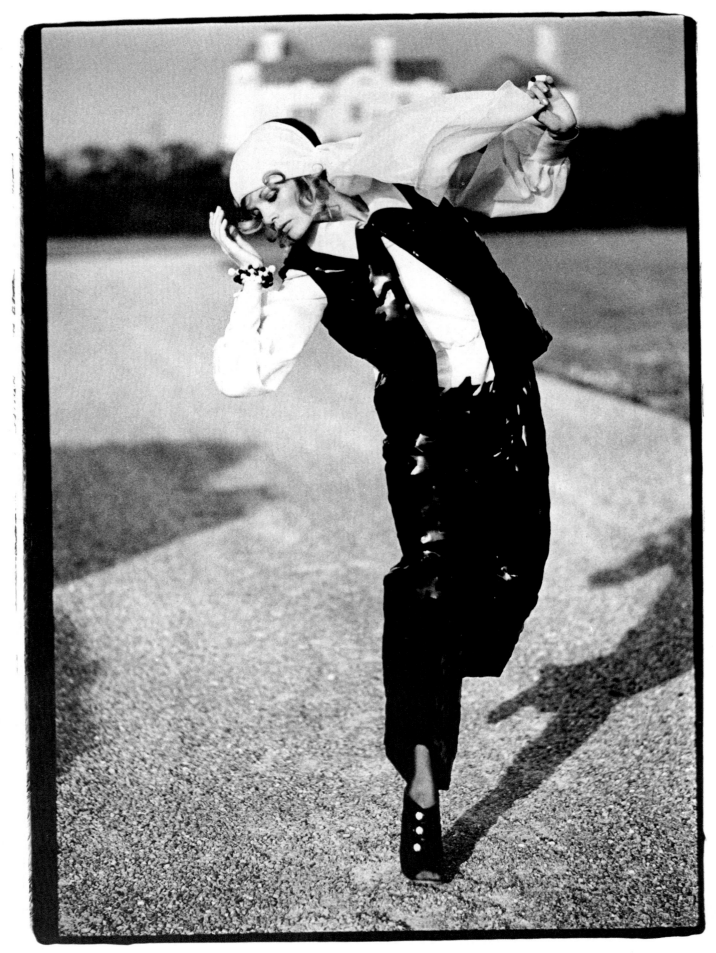

UNTITLED

POLAROID TEST

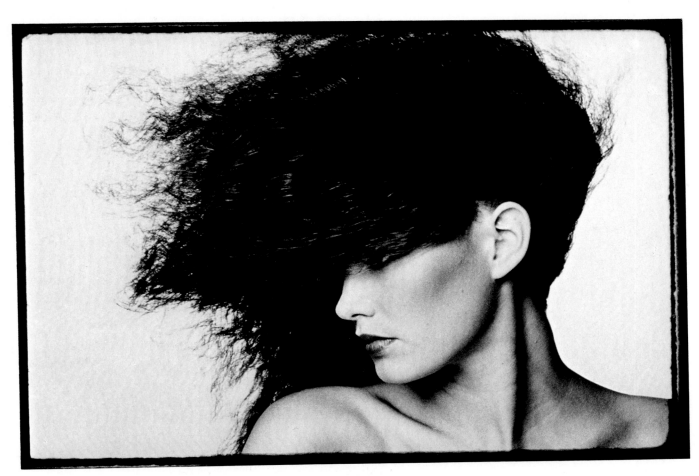

UNTITLED

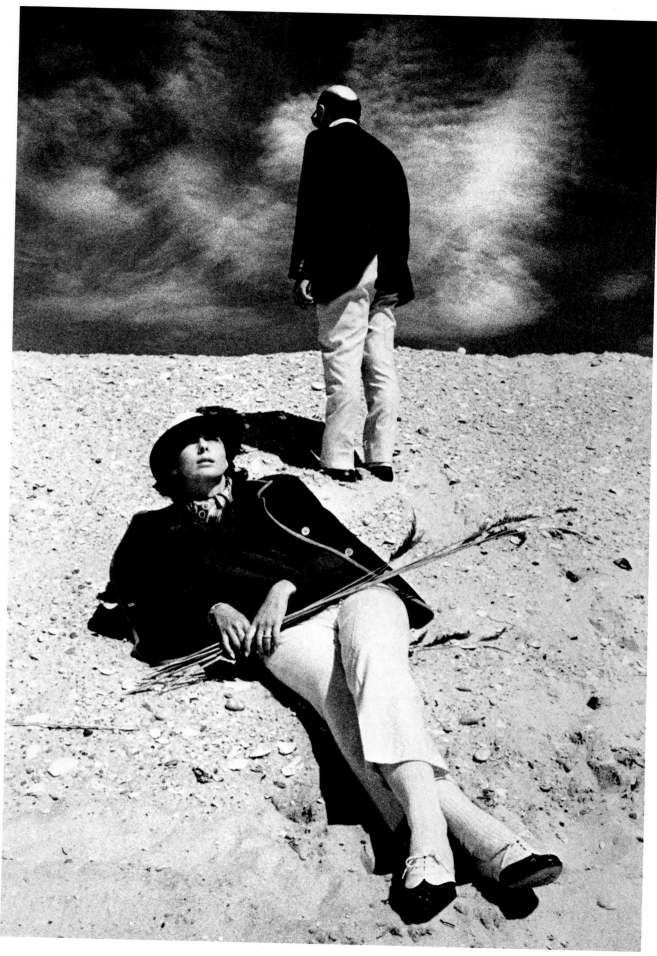

UNTITLED

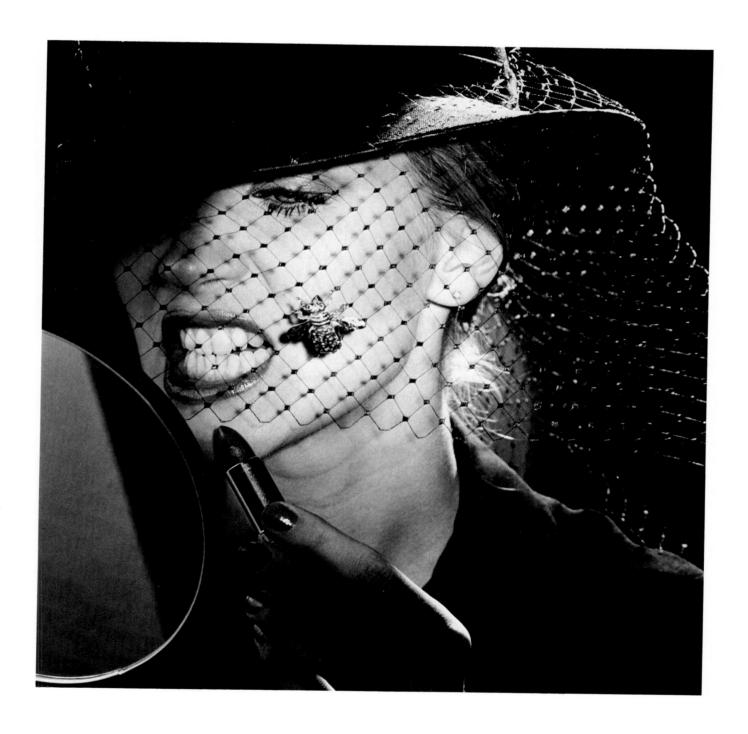

"Fashion has endless possibilities for fantasy because clothes transform us."

JEAN PAGLIUSO

For years I've carried on a love affair with space and spatial relationships. Reality is not as interesting as a sharp-edged image in strange light. A manipulated photograph extends reality. I set up artificial lighting situations that alter perspectives and light much as the surrealists have done.

Fashion has endless possibilities for fantasy because clothes transform us. They are second skins. Models wear clothes for a photograph that they wouldn't wear in real life. They may even get turned off by them. But after a year or so, models become chameleons. I did a shooting with a well-known male model that took him through eight completely distinct changes, from the person he is, to someone he is not. No man would really dress in real life as he was dressed. The pictures were just ideas.

I am affected by my social conditions to try to make my point of view public and visual. But my ability to say something changes each day. On certain days I feel I am giving a powerful and peculiar insight into the workings of a woman. Other days I can see no difference between the model and a chair. I have a compulsion to shoot and can only see it one way. I've decided that it is pointless to try to do anything else. Whatever my compulsion is, I have to live it out until it changes.

When I photograph a woman, there isn't the kind of confrontation there sometimes is between a man and a woman. Occasionally, I even feel that I am the woman in the photograph, that I'm a voyeur looking through a peep-hole at a woman like myself going about her business. I prefer a model who looks intelligent. I think a certain way and hope the person I work with thinks that way too. Most important are intelligent eyes. Having grown up in the 50's with the Debbie Reynolds/Doris Day look, I have a problem with little noses and pouty lips.

Fashion is my facility. I've always been involved in it, although I don't think about what's going on in the fashion world from day to day. I wanted to be a fashion illustrator, so I went to New York. I started working for VOGUE PATTERNS and, in 1966, went to MADEMOISELLE. In the art department, we worked with the stats of photographs and it was up to me to crop the way I wanted them on the page. I could completely change the photographer's original intention and, to me, the stat seemed to look better than the photograph. I kept thinking that I could do as well, if not better. Finally, I left MADEMOISELLE because seniority was a big thing there. I don't have it in me to stick something like that out just for a small niche.

Late in 1966, I went to California and opened a dress store in my home town. The people there don't think the way I do. They weren't ready for my boutique so after two years, I closed

it down and went to Mexico. I always liked painting and decided to discipline myself, which I'd never done, to paint each day for at least three hours. Each day, for two months, I painted and afterwards went out to take pictures with a camera borrowed from a friend. The film was developed in Mexico and reticulation made the pictures look like worms were crawling all over them. I thought that I'd discovered great new process.

When I came back, I took a 4 x 5 photography course at L.A. Trade Tech. I never did learn how to use the format. I'd shoot and run to the darkroom, where they had 30 enlargers in stalls, and start printing the Mexico pictures. In 1968, while working as an interior designer, I put a darkroom in my closet. I'd work until three or four o'clock in the morning on my prints and then work at the office all day. I took some pictures of a friend to the Nina Blanchard Agency and asked if I could test some of her girls. I didn't know you were supposed to do it for free, and I charged the girls $50 to shoot and $10 a print. I would exhaust myself, shooting all day at the beach and the mountains. After testing for four months, I started to get work.

At that time, instead of developing an aesthetic, I wanted to do good commercial work. My goal was to sell Catalina Sportswear and Hollywood Vassarette, so right away the subject was a compromise, rather than saying something personal. When I came to New York in 1974, I found that even when I did editorials, there was something in front of me that I wouldn't normally choose. Only recently have I worked for editors who set no boundaries, at ITALIAN BAZAAR. Within the confines I set for myself, I can do anything I want to do for them.

If I have a client who says we are hiring you because of your talent in seeing a certain way, I tell them they must let me see that way, and they usually go along with it. I listen carefully when the client presents the job and tell him my ideas and see where I must compromise. I'm very clear about those compromises before I go into a shooting. For example, I don't plan a photograph for Revlon the same way I would for a perfume company. Perfume is abstract, while cosmetics are concrete. How a fragrance is interpreted, how the client wants to make a model look and act in an environment, is different from how Revlon mascara is photographed on a girl's eyes.

Usually there is not enough time to shoot one way for myself and another way for the client. If I can do it without changing everything around, I'll take some pictures for myself. I find that almost everybody who works with me expects something more than the average and they make it very clear. If I fall short of that we all know it. I've got to work harder because the girl and I

have an alliance and know that we are there to do something fine.

I work exclusively with the Hasselblad in order to get a fine quality, sharp negative. But it used to be that I was always employing some method of soft-focus diffusion filters, pushing the film, for grain in the print or the negative. I have bad eyes and I really see everything in soft-focus. Also, until recently, I never knew how to focus the camera, and properly develop a negative. For quite a while, peasant dresses and old lace looked better with this softness of '20 s photographs. In the early '60s, I collected fashion magazines and QUEEN was my favorite. David Hamilton was the art director and I was influenced by his soft-focus pictures of the little girls. When I started photographing, I put vaseline on the lens, not on the filter.

One of my early photographs, taken in Echo Park in 1970, has diffused, gradating tones because it was a hazy L.A. day. My beginning craze was to print on Kodalith paper, which reduced tones and sharpness even further. It was shot with a Nikon and a 105mm lens, which isn't as sharp as the Hasselblad lenses.

The picture of the GIRL EATING THE PEACH was taken in 1975, about a year after I came to New York. I used a Nikon and, for the first time, a ring light. I'd seen its effects in VOGUE in the '50s, and I wanted to try to ease my way into a harder line. I wasn't used to seeing a sharp edge and used a star filter on the lens to diffuse and refract the light. This was a beauty illustration for VIVA, so I could do anything I wanted.

I almost always shoot full frame and ask that the art director keep it intact. ITALIAN BAZAAR usually does, unless they decide it doesn't work. I am a purist when it comes to the frame; I never crop a picture. I will shoot with the intention of cropping only when I know a magazine needs a bleed page of an odd size. An exception is the BLONDE NUDE WITH FLOWERS. It was my first job for BAZAAR, in 1977, and at that time, I was coming to the end of a phase in which I would tear and tint my pictures. They let me do anything I wanted for this beauty shot, which was a nice beginning with them. The photograph was made in the studio, with an 80mm lens on a Hasselblad and a ring light.

Shooting men is much easier for me than shooting women. Maybe it is because I relate to men as male photographers do to women. I give men something extra and can't do that for a woman. I deal with a woman's complexities because I am complex. Men are complex too, but I see them more clearly in relationship to myself.

The picture of GARY IN A WHITE SUIT was a test. I usually don't test because so much goes into the completion of a good picture and it doesn't work if I just say stop by and just take out my

camera. But these people called me up so many times. They were active in the runway circuit and kind of crazy. I had known them in California and they were excited that we were all in New York, so I said, "Come on over." Cindy brought a red Halston dress and he brought his best fashion stuff.

She didn't have her dress on right and instead of going into the dressing room, took it off on the set. I said, "That looks great." Her hair was funny, but I shot it anyway and said, "Let's do it again another day, the same thing, but we have to find a way to make your head one small shape." A few days later, with her head wrapped in a nylon stocking, she crouched down in the mirror and it looked good so we just shot it.

It was late day and there wasn't enough natural light in the room to affect the picture. I used a ring light with a bleed-in of tungsten. The ring light fall-off is so drastic after it hits the main subject, that she would have been much darker if there hadn't been tungsten fill. This is one of my favorite pictures but somebody selling a suit would be terribly distracted by the shape in the corner. Somebody appreciating nudes wouldn't want merchandise in the foreground. Commercially, it is at odds but I still think it says something.

In American fashion, the concept is not important. The magazines ask that a photographer shoot with a long lens because they want to see the girl, not the background. It is necessary to find an environment that implies a certain lusciousness of attitude but they crop so tightly that it becomes only an implication.

For me, concept and location are both very important and the turning point comes at the moment the model walks on set. It's exciting when the hair dresser and stylist have given a woman a look that is stylized, because stylization makes my pictures better. I have favorite people for certain types of clothes. Some like to do extreme styles and others are better at a classic look.

The best part of any shooting is a surprise and the less predictable it is, the more excited I get. This surprise can be technical or part of my interaction with the model. I might get an idea that demands a certain technique I have't used before, but those technical problems are solved as part of the natural, intuitive process. Let's say I want to shoot evening gowns in a barely lit environment. I must decide whether to use strobe, which is harsher, or tungsten, which is more seductive and closer to available light. I set about creating the mood and checking it with Polaroid test shots and improve the picture as I go.

I spent a lot of time lighting the lipstick shot. I had one light on the back, one that kissed the top of the hat, to separate it from the black background, and a follow spot on the front. I used to

get nervous and think that everybody was waiting for me but now I don't think about it. Sometimes I shut all the lights off and start over. Each time I get a different effect. Working with tungsten, I can see exactly what I've got. Once I start shooting, certain colors shift and soak up light, but at least I can see the possibilities . . . the shadows and modeling.

The FRAGRANCE AD FOR SAKS FIFTH AVENUE looks like a bracelet shot because I started with a light on her hand and was going to turn on other lights but decided it looked great as it was. There are three tungsten lights, one from behind, one underneath, and a follow spot on the front to give a soft circle of light. The picture looked impressive as a full back page of the New York Times. It was made in 1977.

Sometimes when I have free reign to do what I want, I start out thinking about the personal aspects of what I want to say, and then the technical considerations take over. The picture of a MAN IN A RAINCOAT was for the first issue of MENS ITALIAN BAZAAR and they hadn't formulated their image yet. First of all I wanted to shoot it on the Brooklyn Bridge because it is an archetypically American location and, to Italians, quite exotic. I thought I would have the man being seductive with me as part of the concept, but once I got there, realized the idea hadn't crystalized. The editor was getting some things ready and I was standing there wondering what to shoot. The first thing I did was take a Polaroid. I concentrated on how to see the bridge, and did a test with the sun behind it, creating an incredibly dynamic silhouette which didn't exist in reality. Carelessly, I left the strobe light in the frame, and that picture was so much more interesting to me than my original idea, that I switched. As the shooting progressed, the visible strobe light became a violent intruder as in a film still.

Once I have decided the filtration, I expose for the background or, in other words, I underexpose by two stops. Then I know automatically from the Polaroid how close to the model I must place the strobe to bring up the detail on the coat. My assistant holds the strobe, and where he stands determines the lens I use. If he is especially close to the subject, I can't use a wide angle lens, or I have to put the figure way over to one side. There are lots of things that dictate how I finally see the picture.

Another backlit photograph is the GIRL WITH THE SILHOUETTED HORSE AND MALE FIGURE. We were shooting late in the Sports Palace in E.U.R., near Rome, and the sun had just gone down. I took a reading of the skylight and knew everything would be in silhouette. If I hadn't used a strobe, the model would have been completely dark, like the horse without illumination. My basic exposure for silhouette is $f/11$ at 1/500th of a second. I shot the

whole thing in five minutes, and 2 minutes to expose one roll of film. This photograph is even more beautiful in color with an orange sky.

ITALIAN BAZAAR likes to use younger girls, so often, when I work for them, I shoot 16 year olds, although I prefer to work with women. The GIRL IN THE LACE LEOTARD was taken for an accessory shot, and even before I knew what accessories I had to photograph, I'd formulated my idea. I didn't know how I was going to visually work it out but wanted the girls in the kind of underwear I wore in college—pushup bras and stuff like that. Paul Covaco, a freelance editor of the magazine who did the styling, the hair stylist and makeup artist were all interested in a late 50's-early 60's look. I knew there was a leotard around and I wanted the pubic hair to show, but not be gross or too graphic. The thing was that I had to show a belt. You don't see it but the copy reads "the belt is by…" so you look for it. I had the background in the studio from a Christmas catalogue. I don't think it works particularly well, but that's because I can't divorce it in my mind from the catalogue.

This was shot with a Hasselblad on Tri-X developed in D-76. I'm running a series of tests of 10 developers because I have a grain problem with D-76. I'm trying to get better at what I do because I still don't have clarity and fineness of detail. My assistant Tom develops my negatives, but if it is a really big job—200 rolls of film at a time with five contact sheets of each—then Klaus Moser does it.

Printing plays a major role in what I want to say when I'm shooting black and white. I didn't print for quite some time but I'm doing it now because I've lost out when my negative was misinterpreted in the printing. I want to slow down and get my pictures the way I originally saw them. For a long time I had too many jobs and didn't have a nice darkroom. Now printing is my favorite thing to do. I'm always anxious to be in the darkroom.

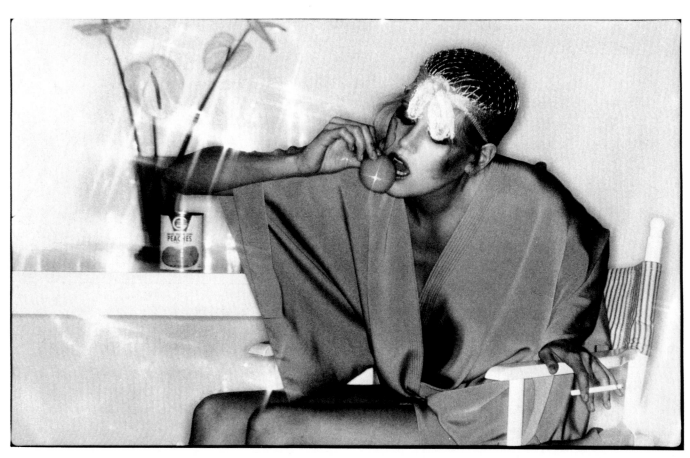

GIRL EATING THE PEACH

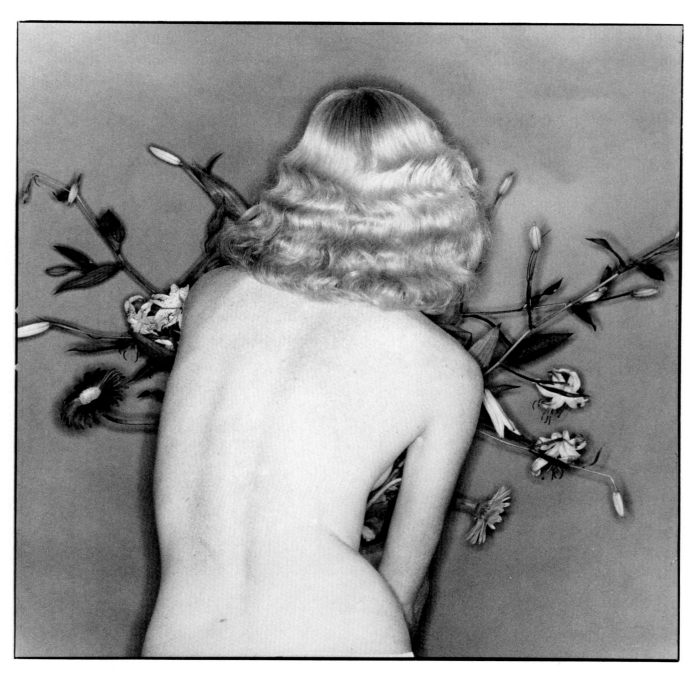

BLONDE NUDE

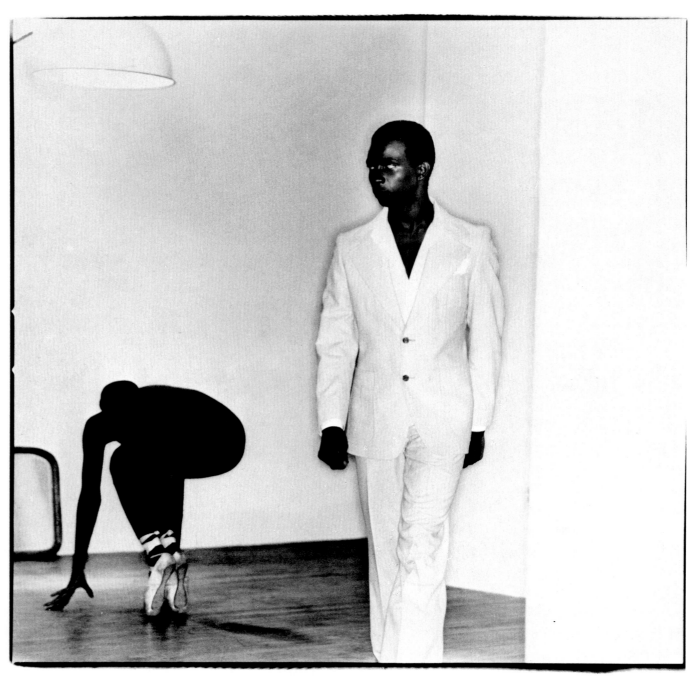

GARY

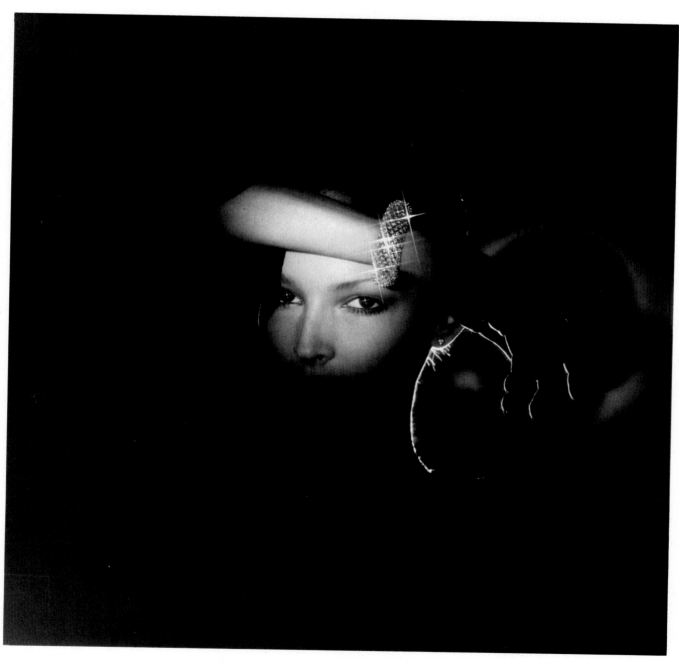

FRAGRANCE AD FOR SAKS FIFTH AVENUE

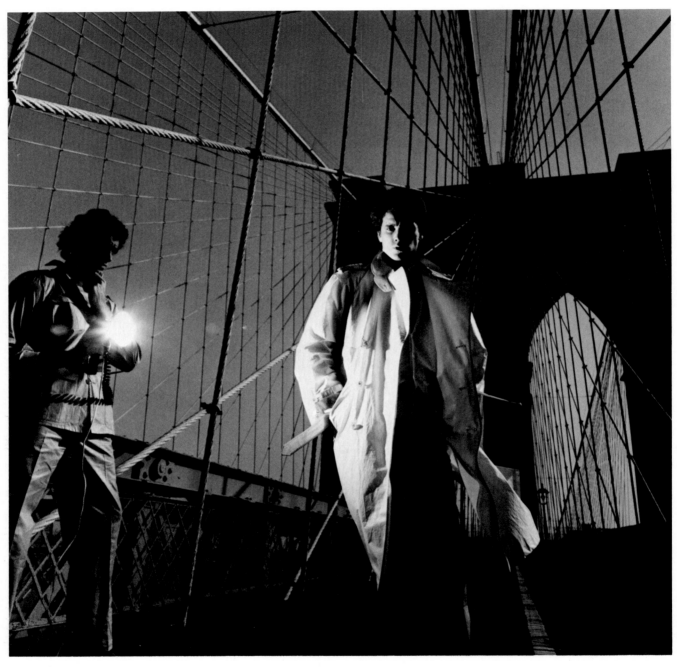

MAN IN A RAINCOAT

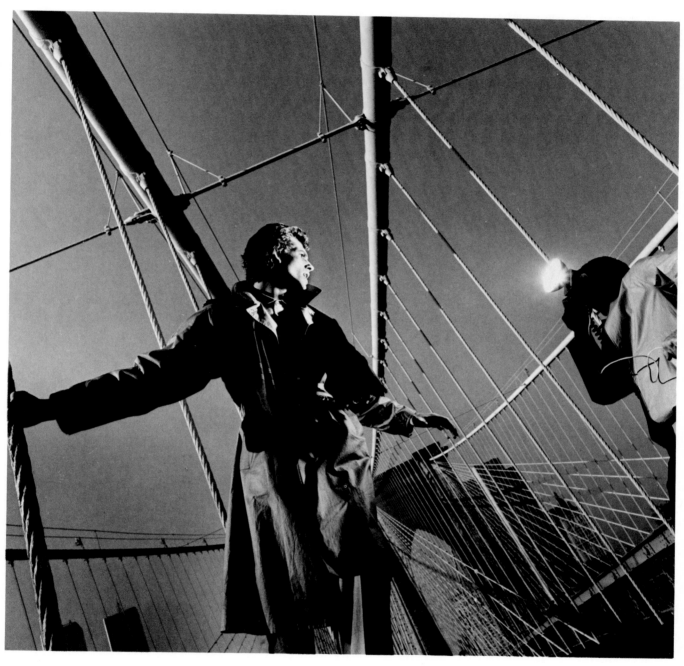

MAN IN A RAINCOAT

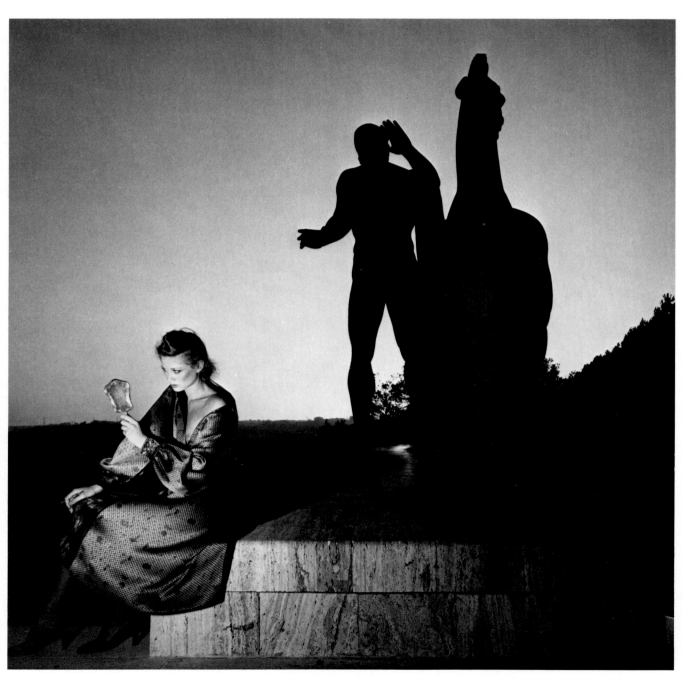

GIRL WITH THE SILHOUETTED HORSE AND MALE FIGURE

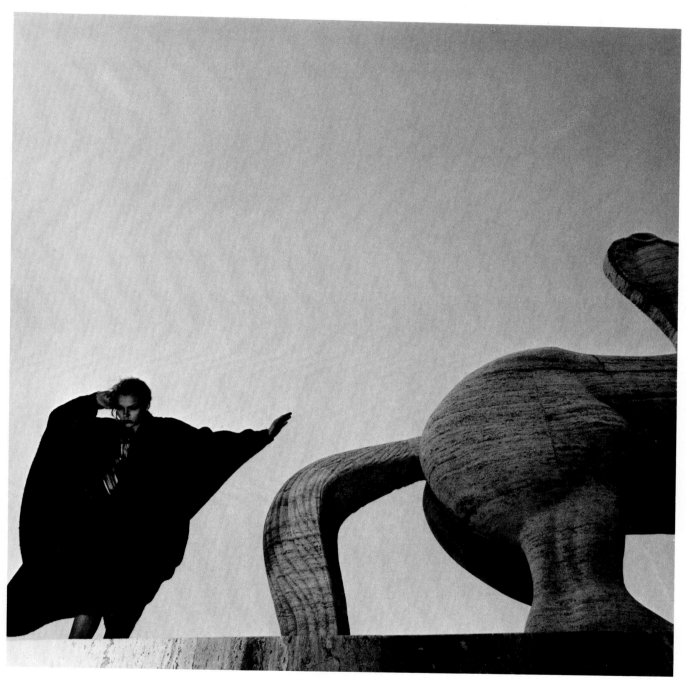

UNTITLED

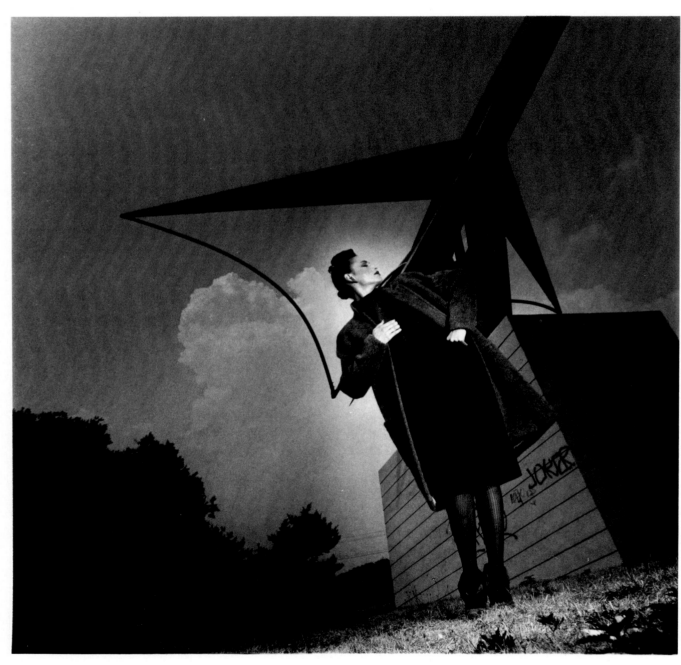

UNTITLED

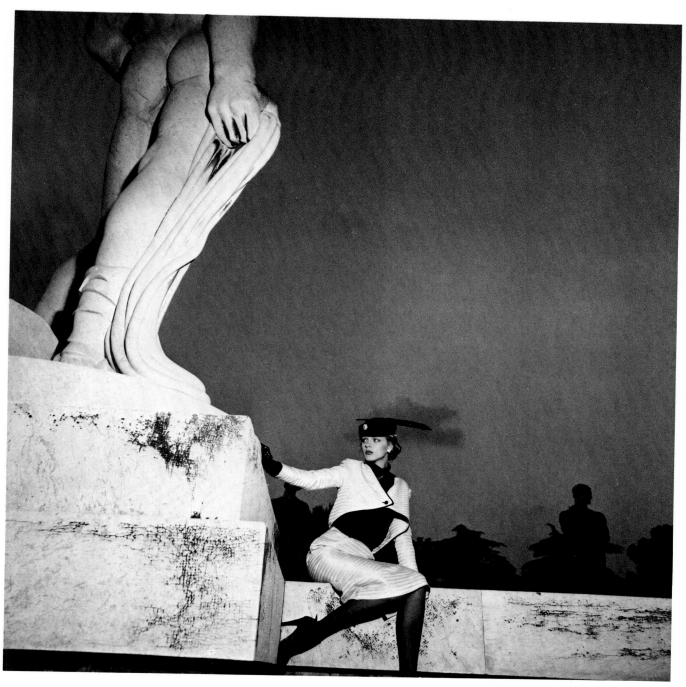

UNTITLED

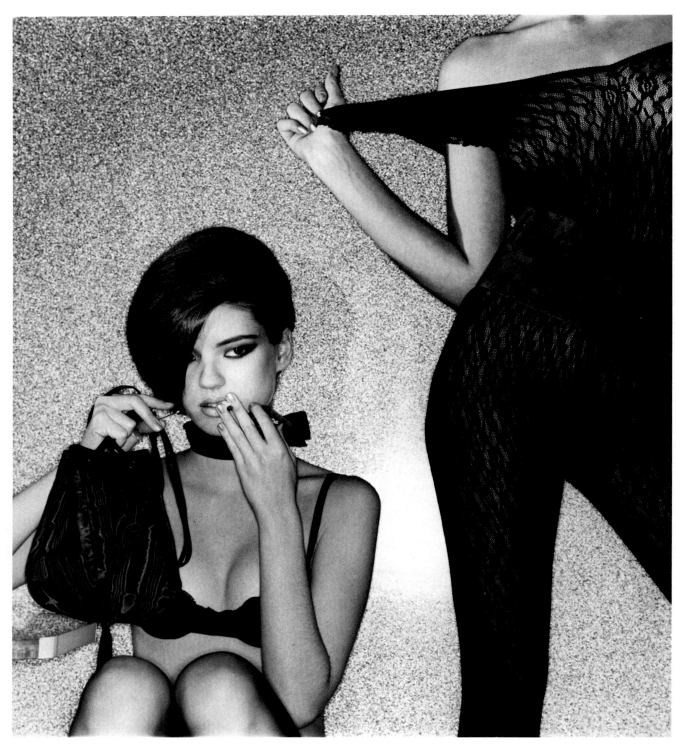

GIRL IN THE LACE LEOTARD

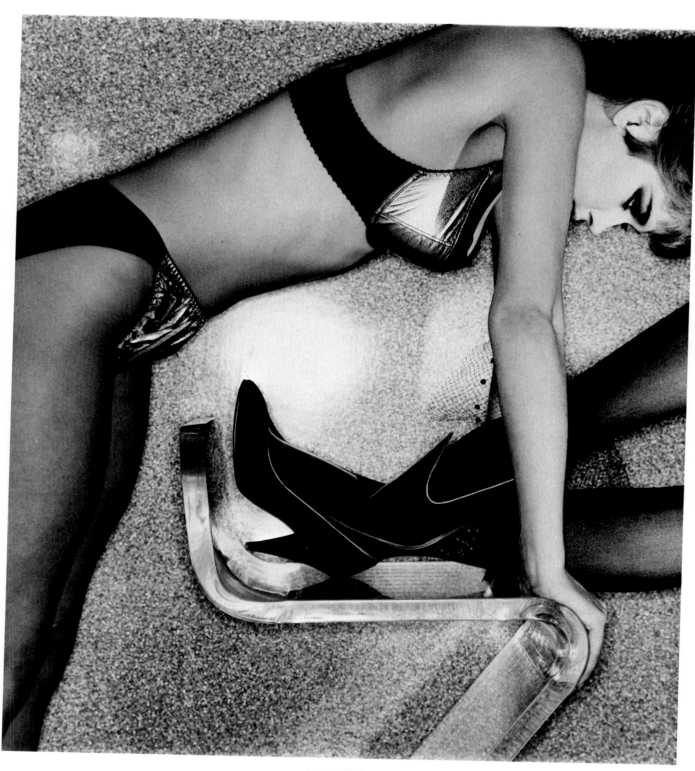

UNTITLED

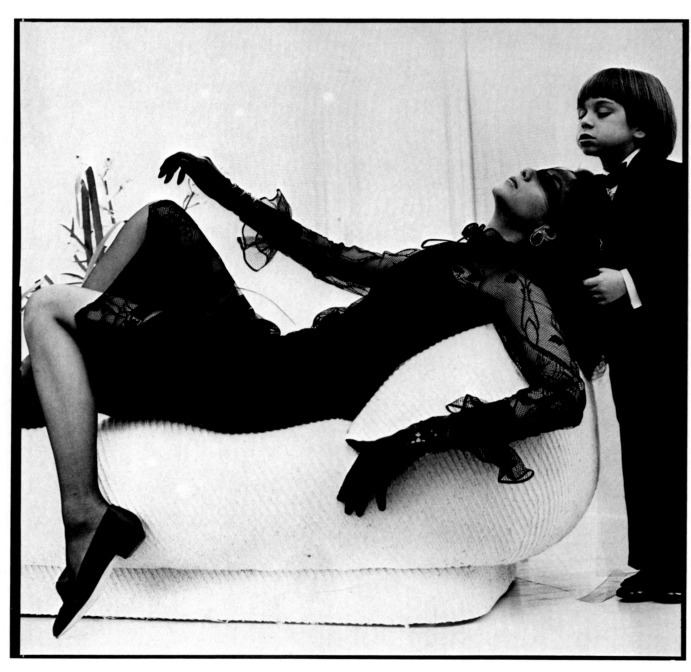

UNTITLED

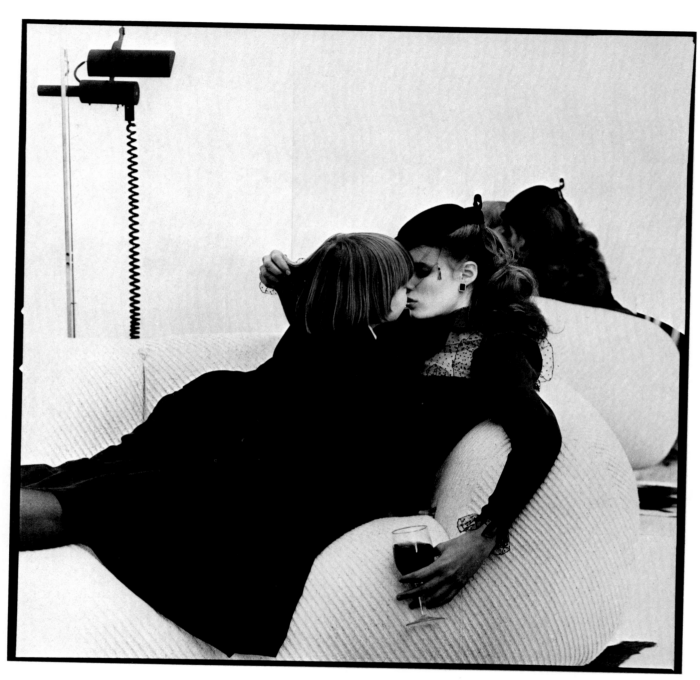

UNTITLED

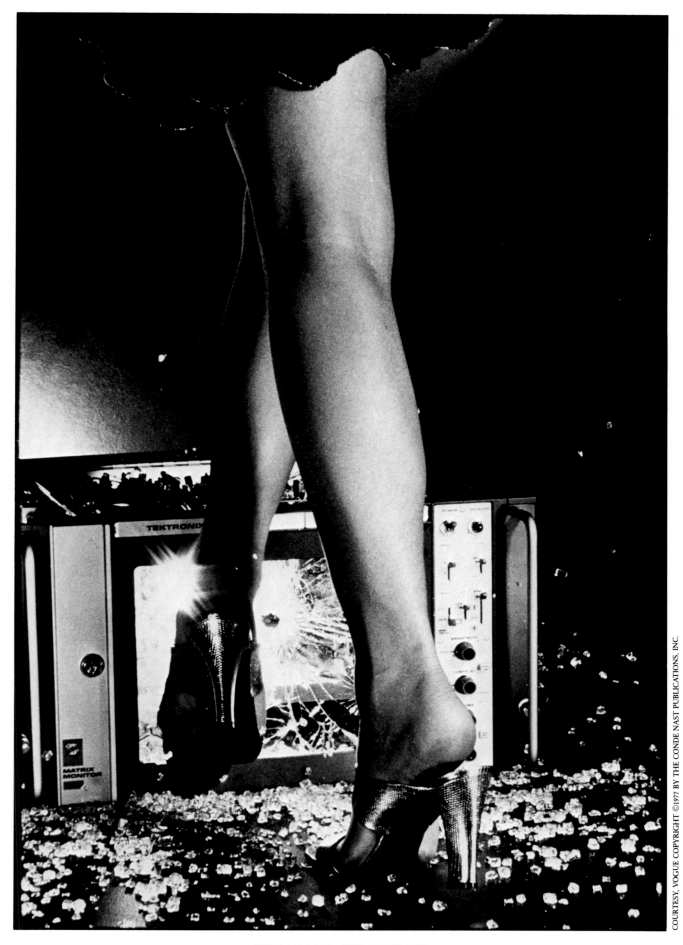

WOMAN SMASHING TV SET

"For me, a good fashion photograph makes a promise it can never keep." CHRIS VON WANGENHEIM

151

Fashion photography is a way to sell clothes. The way to sell clothes, or anything else connected with it, is through seduction.

Fashion photography is basically photography of women. Consequently a woman as seductress sells through fliration and titillation. Physical sex is not necessary, the promise will do. I believe sensuality is the bond.

For me, a good fashion photograph makes a promise it can never keep. By the sheer fact of being printed it appears to be an attainable truth, when, in fact, it is an individual projection of a photographer. It is also unique in that it requires not only a talent in photography, but also a fashion sense.

In general, I give specific instructions to a model. But basically, it's a matter of picking up on a mood. My models pick up the non-verbal communication of what I want them to do.

When my pictures are successful commercially it's at the junction between my creative statement and the supermarket. When a photograph sells in the marketplace, clients don't mind that it works on my level too. The portrait of REGINE AND THE 14 YEAR OLD BOY is one photograph that hit the ideal junction. The implication is that he's her lover and she's the older woman. On the other hand it is nothing more than a mother-son relationship.

I don't plan my photographs to be mysterious. To me they are absolutely straight. I don't like things around a corner. But at the same time I don't like things to be too obvious. The mystery upsets some people, but there's nothing really there.

When I was 12 years old, I lived with my mother in a house in the mountains of Bavaria. A photographer who lived upstairs was a father figure to me. I wanted to look like a pro myself and ran around with two Agfa "Clacks," like Kodak "Brownies."

At one point, I wanted to take a picture of my mother in a beautiful leopard skin coat. I asked her to put it on and come out in front of the house, but she said don't bother me. She didn't trust an 11 year old to take her picture. But I was set to get that picture and manipulated her out. My triumph was a beautiful picture with the mountains and the house. The only reason it didn't work was her sour face—from a fashion point that is.

From that time on I realized that getting my picture was more important to me than the discomfort of someone not understanding, or, someone's opposition to my goals.

When I came to New York from Germany in 1965, it seemed like an escape, but actually what drove me was my incapacity to settle, and to adjust to something I did not believe in. I had studied architecture because photography was unacceptable to my family, but I admired American fashion photography and identified with it more than what I saw in Germany. Because of

language problems, I shuttled from darkroom to darkroom, two weeks here, a month there, odd jobs. Finally I found a full time assistant's job for two years, until 1968.

At that time, I began at HARPER'S BAZAAR doing the little pictures in the back, what's called the ghetto, accessories, boutique stuff. I threw my heart and soul into experimenting and then, in the summer of 1968, when most people were on vacation, the art director decided to give me eight pages. I pulled it off but it was very nerve wracking because BAZAAR was a big affair for me at that time. I didn't even have the heart to look at the contacts, and when I got word it was pretty good I was just beside myself. Another assignment came soon after and I did some editorial pages with the cast of the musical "Hair". They turned out better than I or anybody had anticipated and consequently I got cold feet. I got scared because I didn't have enough experience. I hadn't gone through the mill of working for other magazines. There wasn't much room for failure on a magazine with a staff of photographers which had included Hiro, Avedon, Guy Bourdin, Jimmy Moore and Bob Richardson.

In 1969, I went to Italy and started working for ITALIAN VOGUE, which meant an opportunity to do experimental work. I took a deep breath and began to work without pressure for the first time. I worked with shock effects, which do not have any photographic value, but extended my visual boundaries. During that time, I would shuttle back and forth from Europe six or eight times a year.

About that time I went through a phase of being hot to go to Vegas. Helmut Newton said, "My dear boy, that's something you've got to get out of your system." When the dream assignment came from VOGUE, to go to Vegas to do the Bob Mackey costumes in the shows, I couldn't wait to get there. It was terrific when the girls came out in their bare tits, but once I looked more closely under tungsten light, I saw the silicone, huge lashes, pancake make-up. It was a disaster. I worked my ass off to light them to cover up those problems, and what did I come up with? Those little chromes you can buy in Pigalle. Later I called Alex Liberman and said it didn't work, and he said I should have taken them out into the sunlight. He was right, that was exactly the thing to do, but I couldn't see it because I was in a technical quagmire. In sunlight it would have made a terrific statement about Vegas. I will do it one day.

The picture of the TATTOOED GIRL was taken in 1978 for HARPER'S BAZAAR. Tattoos always fascinated me and when I got a wide open beauty assignment, I used it as a pretext to create a picture for myself. You can get away with this better in Europe

than in the United States, and ultimately, they didn't publish it. They decided to zero in on parts of the body, face, legs, bosom, which, when isolated, become abstract like still lifes. I find it difficult to photograph a piece of the body. The whole is much more erotic.

When I'm excited about a picture, technique falls into place without my thinking about it much. The minute I have something to say, the form will follow. I have an intuitive sense for lighting and just throw the strobes on. I might shoot a Polaroid and move the lights around, but it's not a conscious decision or a precise formula I follow. This shot was lit with my old Balcars I call the "Grannies." They constantly break down but that's alright. My ears subconsciously know if all the flashes go off. If I have five it's like an orchestra. If one is missing, I hear it.

The blue plexiglas background is in many of my studio pictures. The crisp, cold surface counterbalances the warm textures and tones of the body, and the emotional content of the photograph. It has a modern clinical feeling.

The tattoo was shot with a Nikon, in color. I usually test all the emulsions on the market and pick one. A good emulsion glows and I'm not talking about the reds and pinks. There's a three dimensionality and richness to it. My choice is subjective and has nothing to do with Kodak's scientifically correct color balance.

Photography is a highly unscientific medium but that's the charm of it. In order to be creative, one must be willing to endure uncertain outcome which, in a sensitive person, produces anxiety. Once you've got it down pat and stop taking chances, the flame goes out. When the adrenaline stops flowing, it becomes a bore.

The photograph of CHRISTINE, my daughter, was a major shift in my outlook. I found that to have babies and a stable family life doesn't exclude bonheur and eroticism. As it turned out, it deepened certain experiences. At one point, I said to myself, "If that's how I feel, if Christine is whom I love, I should be able to photograph her." I shot it with a Hasselblad on seamless. I knew from experience that a 2¼ negative would give a better range of tonalities than 35mm. A baby's face is detailed and expressive, but there's no bone structure yet, the eyebrows and lashes are blonde, the skin is white. Once you hit it with flash, it all washes out.

The film was Plus-X 220 developed in D-76. Usually I rate my film slower than recommended, for a denser negative. On the whole, I find it is best to develop normally, by Kodak's instructions. I could muck around and get better results but usually one method fits only one type of lighting. Since I don't have a studio or outdoor lighting formula it's best for me to stick with a middle of the road system. I like Tri-X in 35mm. Plus-X in 2¼

format has good constrast without the graininess, a nice gutsy feeling without being too slow.

THE GIRL BEHIND THE FENCE was taken after an assignment for VOGUE in the studio. Usually my mind has been so drained by an assignment that when I come around to doing personal stuff afterward, the jump is too big. But I wanted to do a nude of Gia behind the fence, which is held up by an assistant on either side. It was shot with a Nikon, on Plus-X developed in D-76 straight, with two "Grannies", bang-bang.

The nude is a counter point to the baby picture, which has no fence. To me, the baby is perfect and pure. She has falcon eyes that haven't yet acquired the filtration for how they perceive the world. The older one gets, the more imprisoned one becomes.

There is no ideal body for a nude. It's all in the context in which it's seen, what turns me on at the time. Gia has a great figure, unbeatable, the best tits in the business. By the same token I like no tits at all. A clothed model is something else, a clothes hanger. In fashion, the prerequisite is that a woman be thin, with good legs, hands and face. For a nude any body could be used. I even find scars interesting.

THE WOMAN WITH THE HORSE—if you ask me now—is a symbolic family portrait. There is the riderless horse and a woman with it. I grew up with my mother and sister. My father rode horses and is dead. This horse came up to the studio in the elevator, bucked a bit, then made his ca-ca. I had a good assistant who shoveled it up. The girl knew the horse very well. She was a rider. By the way, I don't think of these things beforehand. I don't embellish my photos with symbolic meanings.

The photograph of THREE PEOPLE FROM ABOVE was shot in Halston's house. It's a beautiful house and very graphic. I decided to shoot from a stairway, from a high angle down, because all the elements, couches, furniture, windows, didn't work straight on. To take a party scene from a high angle emphasizes a feeling of voyeurism. It's like being in Paris and contacting Madame so-and-so, who invites us to her chateau. A little tableau is created for us to watch.

This was an editorial shot for VOGUE, with Christie Brinkley, to show the dresses. I used a side wash light the height of the people, with a fill. Sixty percent illumination came from a strobe at lower right, 30 percent from the upper left, and 10 percent from the camera. I lighted it that way for a feeling of available light. A fan was on in the lower right hand corner to lift up the hair. This way we have the feeling she's lying on her side.

The GIRL IN FRONT OF THE BURNING CAR was shot in Brooklyn. Long before the song "Accidents Never Happen in Real Life", I

felt they did, and should be incorporated in photographs. Obviously this accident was a car getting smashed up by a beautiful woman.

To give a documentary feeling, I used one frontal strobe and the fire illuminates the rest with the help of one strobe in the back as a fill. You can see the light stand by the wheel.

The photograph of the GIRL TIED TO THE TREE was done while shooting for VOGUE PATTERNS at a lodge in Montauk. The model was Karen Bjornson, one of the brighter, funnier girls in the business, somebody you can tell jokes to with a straight face. We had done so many pictures that day, we were tired and one of the crew did something crazy. Karen stood there saying, "I can't go on anymore." I said, "Tie her to the tree, she has to stand up." By the time the joke was over, I saw I had a pretty good picture.

I prefer to use 35mm on location because it's versatile and also, the rectangle fits the page. Two and a quarter is an odd format—it loses a lot in cropping. To say I don't like cropping is putting it mildly. I shoot to the edges unless the art director asks me to leave room around the picture. It throws me off in visualizing the image. There's no sense fighting about it. I get paid to be cropped.

The GIRL STANDING ON HER HEAD was done for the Rizzoli show, "Fashion and Fantasy." I love the scar in conjunction with the pubic hair—a closed opening. The light is a standard "Grannie."

The CHRISTIAN DIOR AD FOR SUNGLASSES I always loved. Capable, authoritative woman are erotic and a turn on; goddesses I definitely hate. The gun had blanks in it, and was sound synchronized with a special strobe—the type Edgerton used for his bullet pictures. It goes off at a 30,000th of a second and can be triggered in different ways. Normally real bullets fly through a beam of light that trigger the flash. Since I worked with blanks, to trigger it with sound, I had to work out the correct distance from the gun to the microphone. A delay mechanism set off the strobe when the sound reached the microphone. The strobe, microphone, and gun were in close proximity in order to catch the flame when it shot out.

Fashion pictures are ephemeral. Some pictures have a great timeliness and draw the reader in but do not hold up as photographs. When you look at them ten years later, you've forgotten the fashion, and you see them more objectively.

I'm competitive, but being different is not good enough. I can make a page stopper for a magazine, let's say, by turning models upside down when all the others are upright. But it's meaningless. I say "wow", but when I look closely, I realize it's nonsense. It's a page stopper but after a moment my mind throws it away.

I'm only as good as the art director who gets my pictures and has the final power to accept or reject. When I work for a magazine I have no control over the fact that color is changed to black and white which, can be disheartening. Therefore I try to view my job as finished when I deliver the pictures.

At times, one of course prostitutes oneself. It's just a question of price and, when I was beginning, when I needed the money, I stooped quite low. But deep down I knew it was a dead end road. The secret is never to sell out totally. There's work around that doesn't pay enough to wreck your nerves over. You can accept 100 percent of the jobs and do consistent work without feeling, but you'll be burnt out fast. I've had agents who wanted me to work every day and make a fortune. But it's important to have rest periods to regain access to your intuition.

The critical issue is breaking the established success formula. It was difficult, for example, when the impressionists rebelled against the academy. Honesty and security in oneself is the key. Anybody can make money, not everybody knows the truth. The thing we all bitch about is a desire for art and the buck, too. Rarely can you have both! One fashion photographer, as an example, who broke the "academy" was Martin Munkacsi. Think of all the perfect lighting, poses, elegant dresses, all in the studio at that time. Then think of the Hungarian who took his models to the beach and had them run and jump. His pictures were not always sharp, but they had spark and soul. Six months later, he became a sensation, and hundreds of models were jumping around. They're still jumping today. Fashion is incestuous.

It is very difficult to make any kind of definitive statement about fashion photography since the medium, by its very nature, is a transient one. Anything which holds true today ought to be changed tomorrow, so by the time this book reaches publication I'll regret having opened my mouth.

REGINE AND THE 14 YEAR OLD BOY

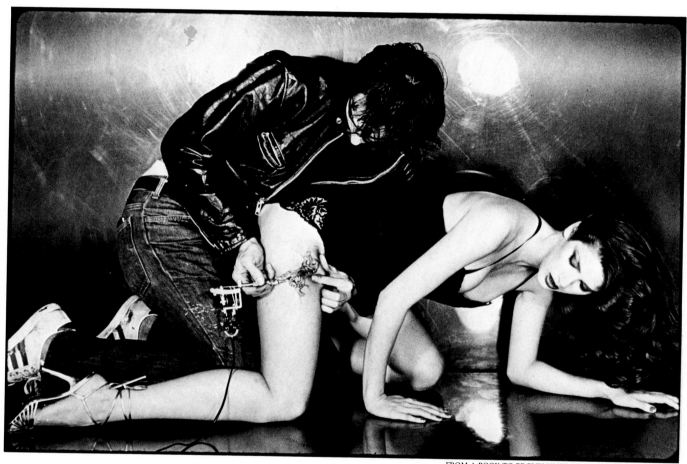

FROM A BOOK TO BE PUBLISHED BY ST. MARTIN'S PRESS, INC.

TATTOOED GIRL

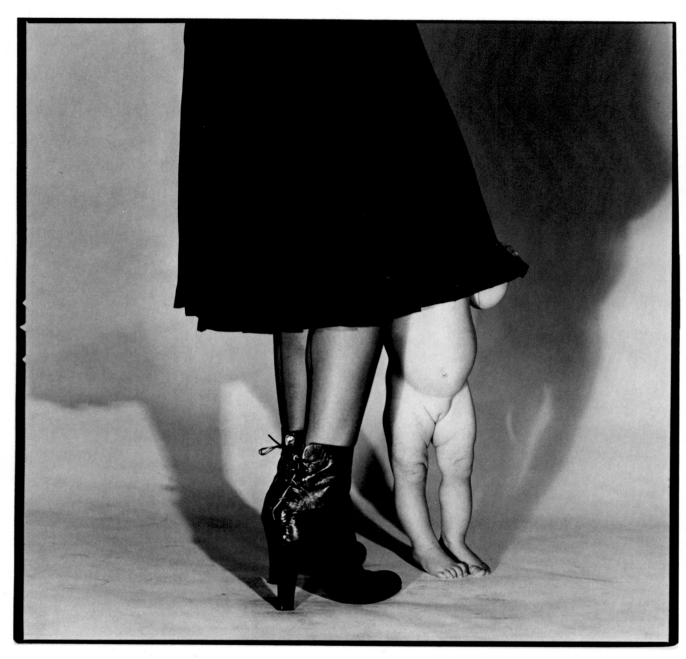

CHRISTINE

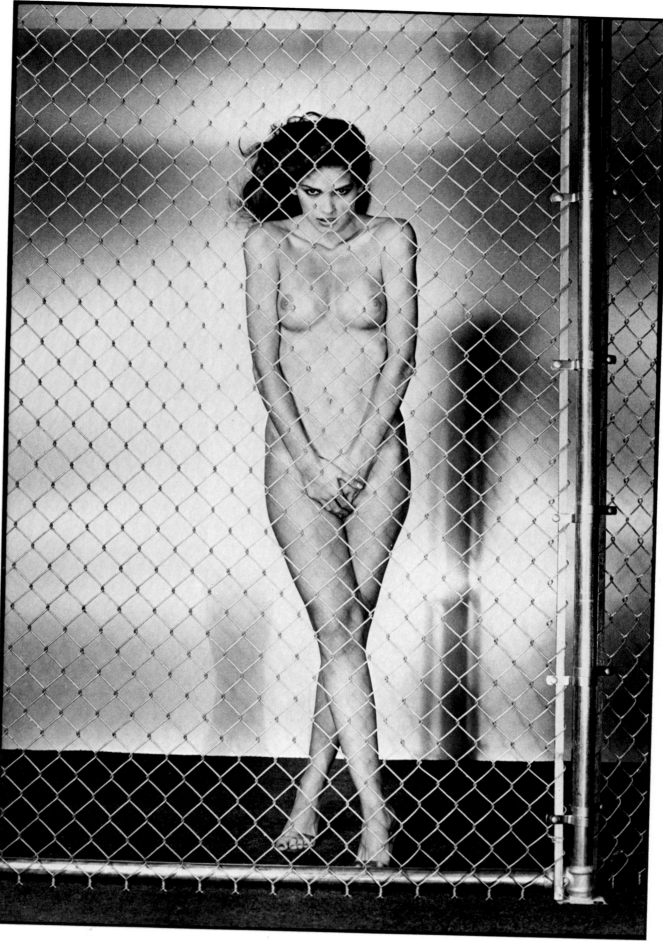

THE GIRL BEHIND THE FENCE

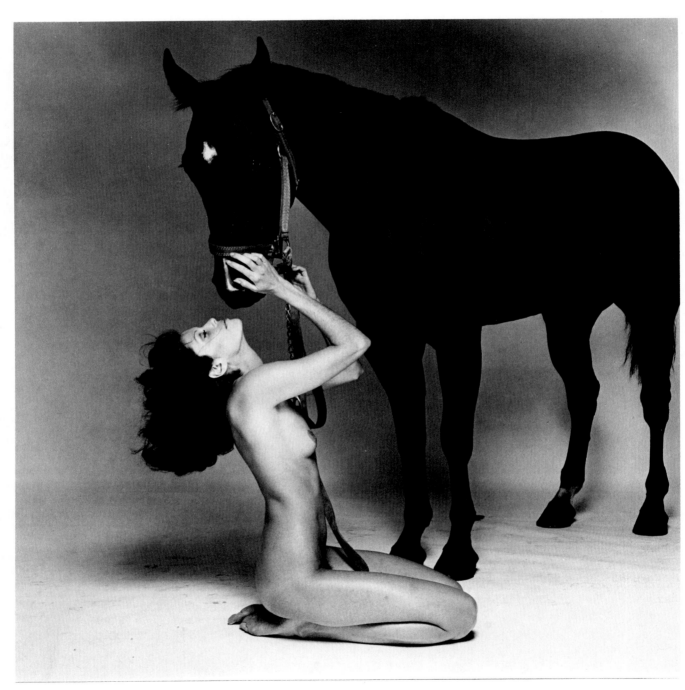

THE WOMAN WITH THE HORSE

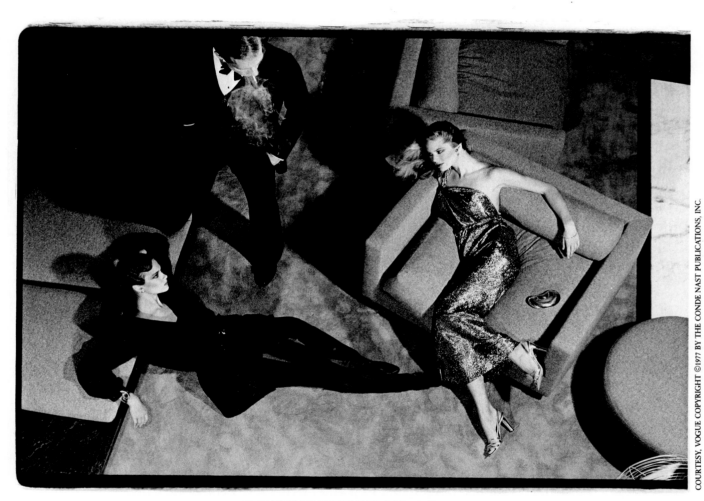

THE THREE PEOPLE FROM ABOVE

163

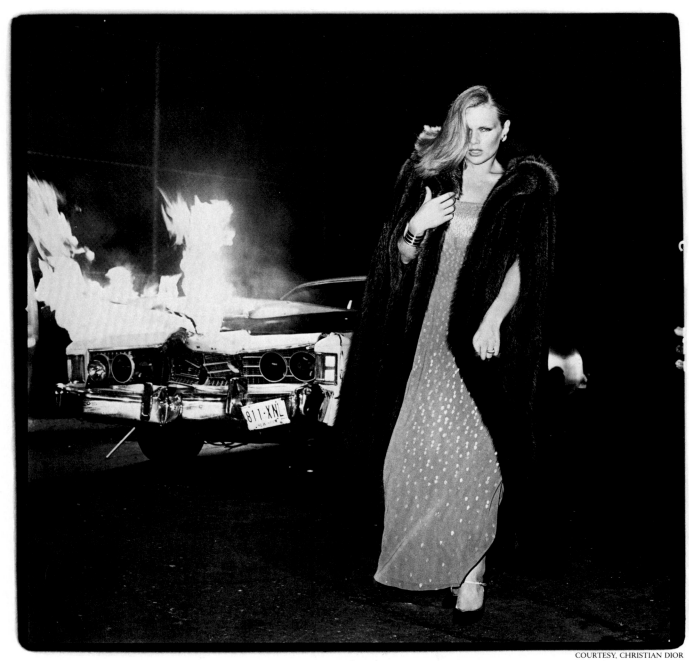

GIRL IN FRONT OF THE BURNING CAR

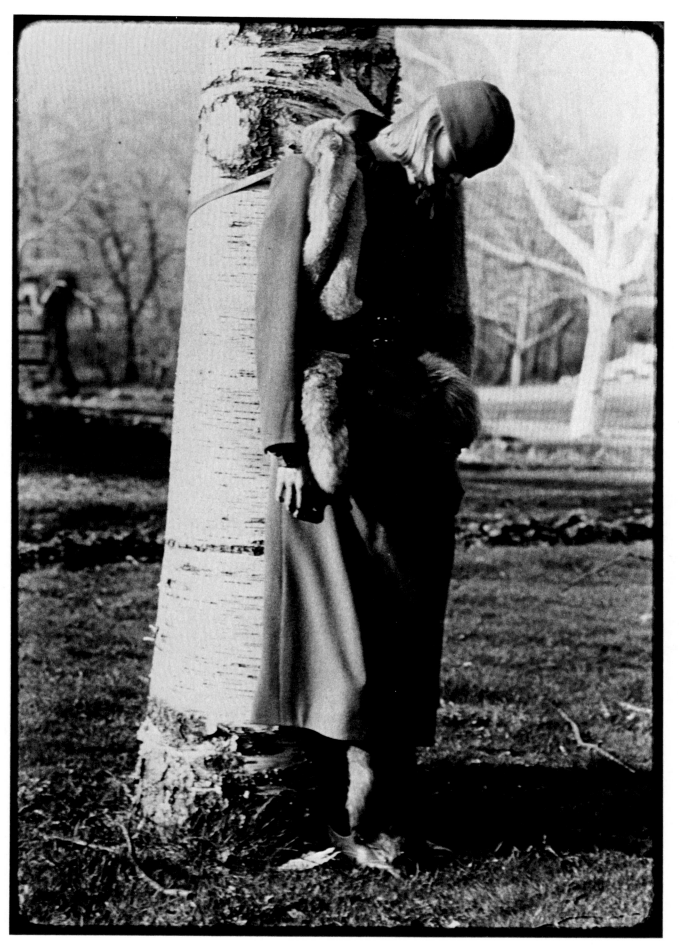

GIRL TIED TO THE TREE

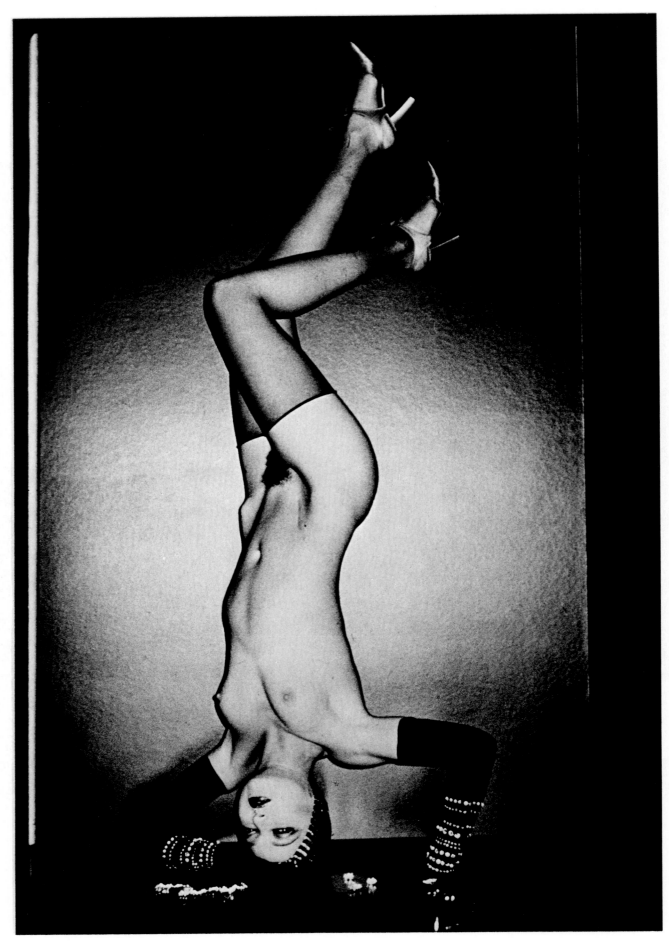

GIRL STANDING ON HER HEAD

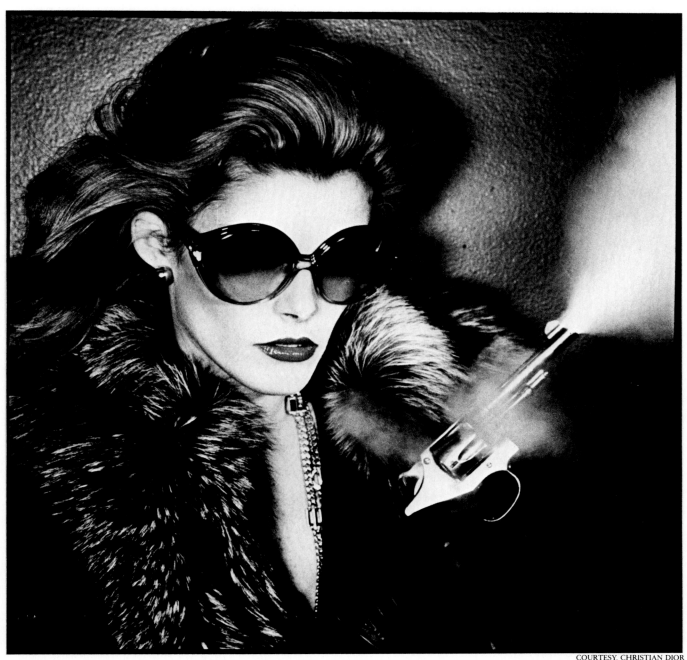

CHRISTIAN DIOR AD FOR SUNGLASSES

HELICOPTER SHOT